Digital
Manga
Techniques

CREATE SUPERB-QUALITY
MANGA ARTWORK
ON YOUR COMPUTER

HAYDEN SCOTT-BARON

A QUARTO BOOK

Copyright © 2005 Quarto Publishing plc

First published in the UK in 2005 by
A & C Black Publishers
37 Soho Square
London W1D 3QZ
www.acblack.com

ISBN-10: 0 7136 7475 X
ISBN-13: 978 07136 7475 0

Conceived, designed and produced by
Quarto Publishing plc
The Old Brewery
6 Blundell Street
London N7 9BH

QUAR:DMT

Project editor Liz Pasfield
Art editor Anna Knight
Assistant art director Penny Cobb
Copy editor Chris Middleton
Designer Karin Skånberg
Illustrators Hayden Scott-Baron, Selina Dean,
Emma Vieceli, Laura Watton
Indexer Pamela Ellis

Art director Moira Clinch
Publisher Paul Carslake

Manufactured by Provision Pte Ltd, Singapore
Printed by Star Standard Pte Ltd, Singapore

9 8 7 6 5 4 3 2 1

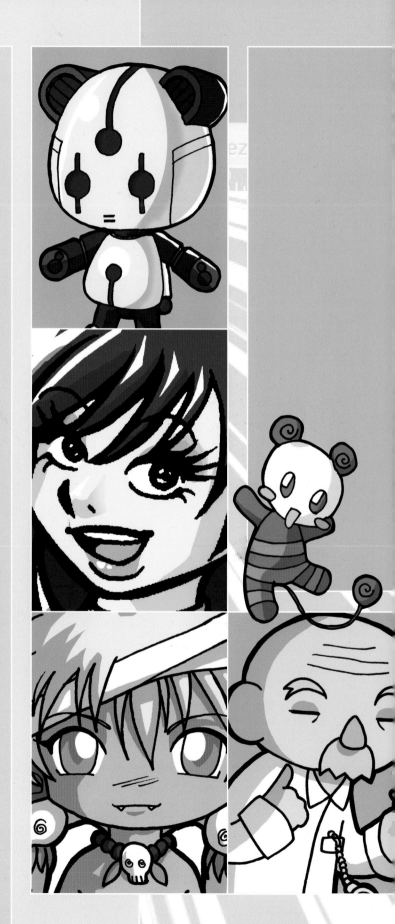

Contents

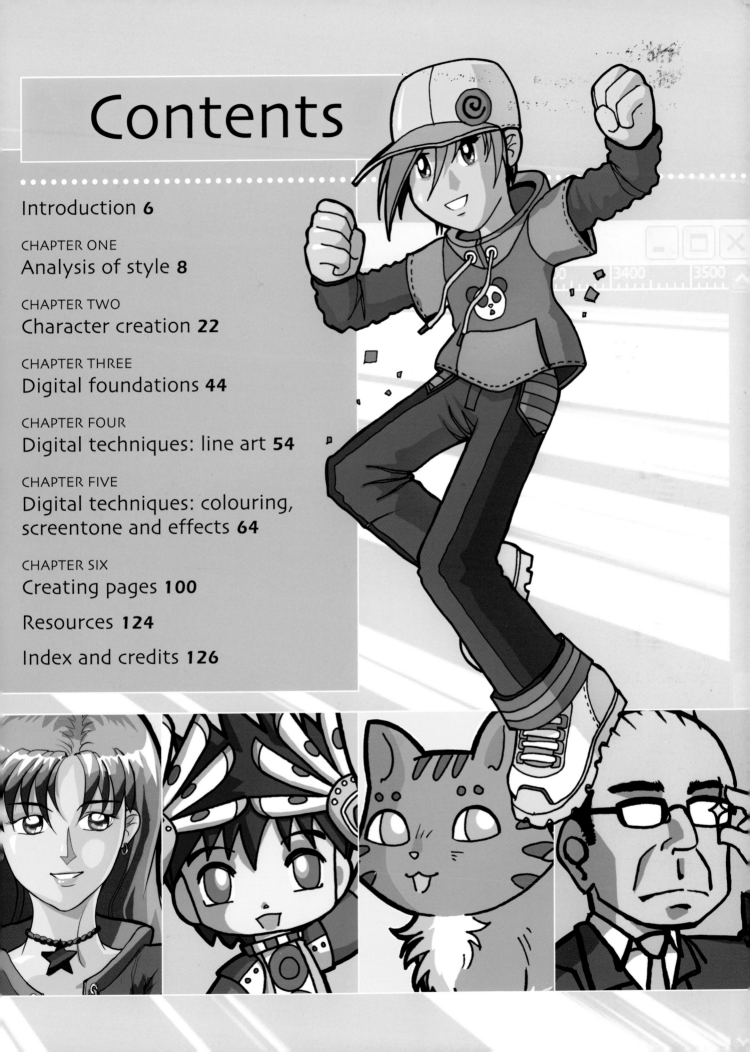

Introduction **6**

CHAPTER ONE
Analysis of style **8**

CHAPTER TWO
Character creation **22**

CHAPTER THREE
Digital foundations **44**

CHAPTER FOUR
Digital techniques: line art **54**

CHAPTER FIVE
Digital techniques: colouring,
screentone and effects **64**

CHAPTER SIX
Creating pages **100**

Resources **124**

Index and credits **126**

Introduction

Manga in its present form has existed for over fifty years, but the origins of Japanese sequential art date back to Ukiyo-E art from the nineteenth century. Hokusai, a famous Ukiyo-E artist, is generally credited with coining the term *manga* meaning literally "irresponsible pictures". The development and social acceptance of mass-produced artwork and sequential art in the early twentieth century, combined with influences from European and American strip-panel comics, evolved into what is now commonly known as manga.

Manga has grown and developed as an art form considerably over half a century in Japan, and has also enjoyed popularity in the West for almost half of this time. The acceptance of the manga style and its iconic imagery into a modern subculture as well as mainstream entertainment has emphasized its place on the world stage. New generations have grown up with manga as a major artistic influence, through cartoons, video games and the popularity of printed manga. There's little wonder, then, that so many Western artists are creating great work with the manga aesthetic!

▼ Line art styles
Delicate and minimal use of line art captures a charm and grace, keeping the focus solely on the characters themselves.

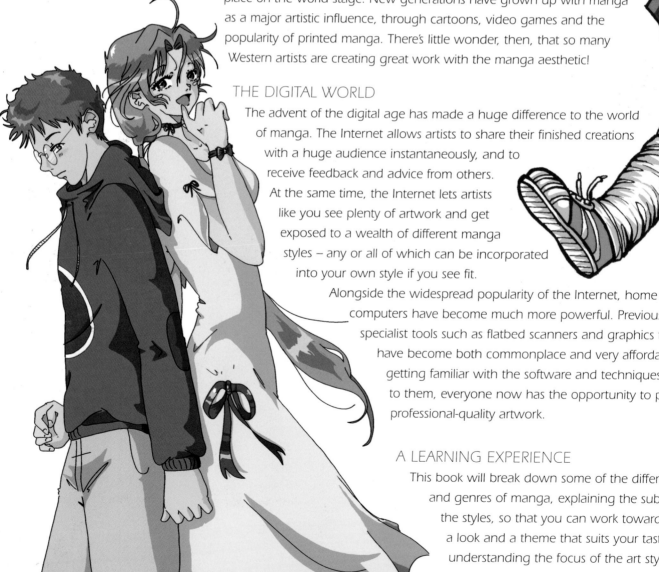

THE DIGITAL WORLD

The advent of the digital age has made a huge difference to the world of manga. The Internet allows artists to share their finished creations with a huge audience instantaneously, and to receive feedback and advice from others. At the same time, the Internet lets artists like you see plenty of artwork and get exposed to a wealth of different manga styles – any or all of which can be incorporated into your own style if you see fit.

Alongside the widespread popularity of the Internet, home computers have become much more powerful. Previously specialist tools such as flatbed scanners and graphics tablets have become both commonplace and very affordable. By getting familiar with the software and techniques available to them, everyone now has the opportunity to produce professional-quality artwork.

A LEARNING EXPERIENCE

This book will break down some of the different styles and genres of manga, explaining the subtleties of the styles, so that you can work towards finding a look and a theme that suits your tastes. By understanding the focus of the art style and

the distinctive visual techniques, you can begin to develop your artwork in a way that suits you – and with confidence!

Whether you wish to work on single illustrations or go a step further and create your own manga-style comics, this book will guide you through the process. Methods of character design and applied examples will help you to see the possibilities of the medium, and the sections on story will help you give your characters a believable life all of their own.

Everything from advice on creating a world for your characters to choosing how to dress them will help you develop your own cool and stylish manga characters.

A LIFE OF MANGA

Producing manga over the years has afforded me no end of happiness, with each picture representing a minor personal victory. The endless range of styles and subject matter has enabled me to skip between mature and realistic drama to cute and happy illustrations easily and comfortably, instilling me with a certainty that I can apply my skills to whatever suits me at the time. The experience of seeing a project through from the early pencil strokes of a character design to the completed story in print is incredibly satisfying. There's a lot of hard work involved – but it's that hard work that lets you know that what you've produced is the very best you can manage. I look forward to developing my skills further and to working on more comic projects over the coming years.

▲ Colourful characters
Schoolgirl characters are popular in manga as they capture a spirit of innocence and youthful enthusiasm.

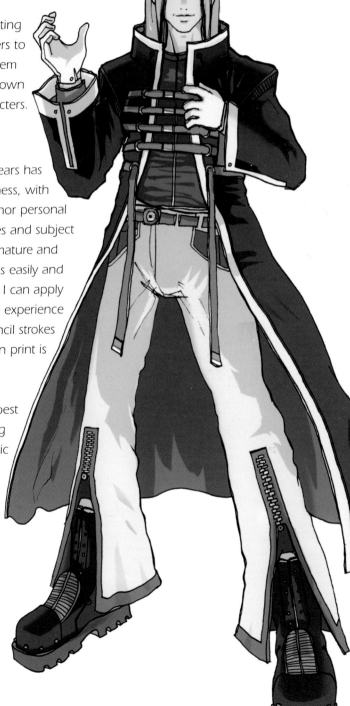

▶ Costume influences
In manga, costumes are often elaborate or outlandish, with a mixture of street styles and military and traditional influences.

CHAPTER ONE
Analysis of style

The word *manga* literally translates as "comics", but has come to refer to a specific style of illustration. There are many common elements of manga imagery that we can identify and use in our work.

 What is manga? **10**

Shoujo **12**

Shounen **14**

Fantasy and science fiction **16**

Action **18**

Comedy **20**

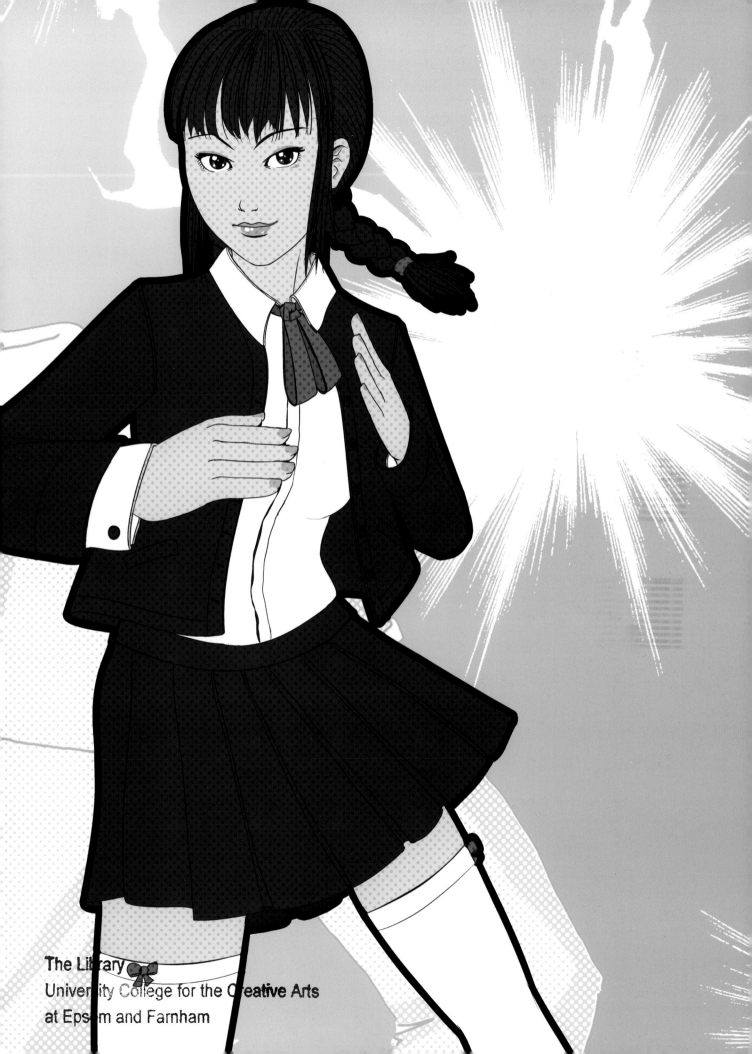

The Library
University College for the Creative Arts
at Epsom and Farnham

What is manga?

Although to non-expert Western eyes the term *manga* might conjure up a single graphic style, it simply refers to Japanese comic art and to the comics themselves. However, despite there being many different visual styles in Japanese comics, there are some underlying elements that represent a shared aesthetic, giving the medium a distinct visual edge.

Stylization is probably the most significant recurring element of manga artwork. The characters are realized with stylish yet clean and consistent visuals that concentrate on the characters' charm and expressiveness.

Minimalism is another readily identifiable characteristic of almost all forms of manga. One of the most important aspects of the style, especially when working on story-based illustrations, is realizing that you don't have to draw every detail – you can achieve a greater effect through the power of suggestion. A simple example would be to look at the noses of manga characters: you'll notice that some artists, when drawing at certain angles, don't draw the nose at all. The reader isn't confused by this, and the image remains clean, elegant and minimal.

Analysing many of the common elements of manga will help you appreciate the nuances of the art form, and apply them to your own work.

Colourful characters
Vibrant colours and the frog-themed clothing reflect this character's cheerful nature.

VISUAL GRAMMAR
Manga artists often use varieties of visual shorthand to tell readers what they need to know about a character's emotions without the need for exposition, explanatory dialogue and lots of extraneous panels. Using such graphic devices lets the artist retain the all-important simplicity of expression that is a hallmark of manga style. These techniques are also useful as comedic devices when using hyperstylization (see Comedy, pages 20–21).

See also **Planning your pages, pages 102–103**

SAMPLE COMIC BOOK PAGE

1. This panel is small, with dynamic cropping. It gives the impression of viewing the scene from a distance before leading into a much closer view.

3. Using a distant "camera", it's possible to show all the characters in the scene at once. Irrelevant details such as facial features are removed from this image as a means of focusing the reader's attention on body language.

5. The hand is shown with sparkles of screentone effects (see page 94), implying an emotional response to whatever is said.

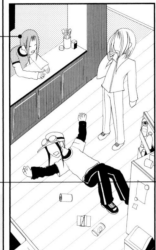

2. Hyperstylization is used here to demonstrate the anger in the face of the boy at the back of the scene. Using screentone effects (see pages 106–107), the character in front is dramatically lit. The panel continues off the page to the right-hand side, giving it a much greater focus than usual and implying that there's even more image beyond the edge of the page.

4. The character is presented against a simple white background with no suggestion of background detail. This allows the reader to focus on the character, while also suggesting that the other characters are focusing their attention on the character too.

6. Using a simple trick, the character has moved his hand to open the cupboard. The position of the previous panel indicates that the hand is attached to this person, but it fluidly leads into a different action.

Beads of sweat
Embarrassment, nerves, discomfort

Bubbles above head
Drunk

Mushroom cloud
Sigh of relief

Vertical lines
Shocked

Bubble from nose
Sleeping

Ghost leaving nose
Dead

Sparkles
Extreme happiness in romantic situations

Pounding vein
Angry

Scribble cloud
Very angry

Chick on head
Innocence

Spiral/helix
Dizzy

Hair bristling
Annoyance, irritation

Hearts
Romance, in love

Shoujo

Unlike the comics industry in most Western countries today, Japan offers a broad and rich variety of comics designed specifically for a female audience, and has done so throughout the history of manga.

Shoujo is the Japanese word for "girl", so *shoujo manga* refers to the comics produced in Japan specifically for girls. As a demographic term, shoujo isn't strictly a genre, but by extension it does refer to the styles of artwork used to appeal to female readers. Almost exclusively these comics are written and drawn by females and offer a visual style serving stories that focus on the emotions of the characters.

With its emphasis on relationships and emotional struggle, the style lends itself to romance storylines, but also to a huge number of stories dealing with more complex and mature plots. As a result, shoujo manga embraces everything from childhood dreams and fluffy animals to violent, sword-wielding, apocalyptic drama, but each story is captured with the same elegance, delicacy and rapturous charm synonymous with shoujo manga.

Shoujo characteristics

There are many characteristic elements of shoujo artwork. Characters tend to be drawn with tall and slender physiques, which bring to mind European fashion illustration and Western ideals. Male characters are often drawn with soft and elegant features, creating a slightly androgynous yet striking look.

Line art tends to be more delicate than other manga styles, with thin lines and long, flowing strokes.

Details aside, visual abstraction is possibly the most remarkable trait of shoujo artwork, where it is common for artists to represent the emotion, beauty and significance of a scene with almost dreamlike visual flourishes. Flowers, sparkles, feathers and wisps are superimposed around the image, and the eyes of characters shine so brightly that they can be seen through the hair draped over them.

Shoujo details
Hair is captured with delicate curls and perfect grooming, and the clothing has an attention to detail and a fashion consciousness that is unsurpassed.

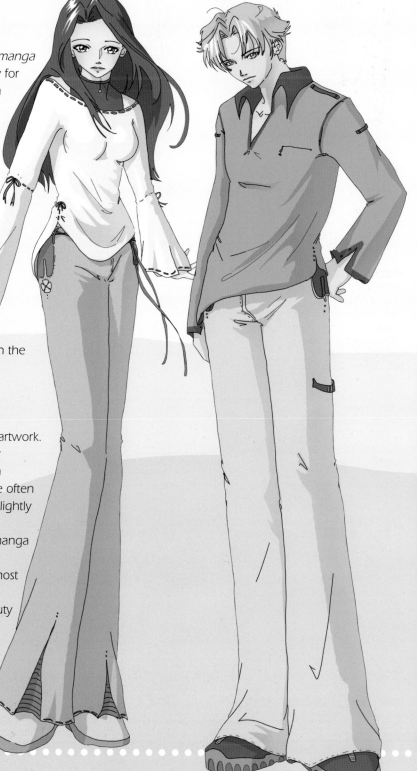

See also **Costume design, pages 40–41**

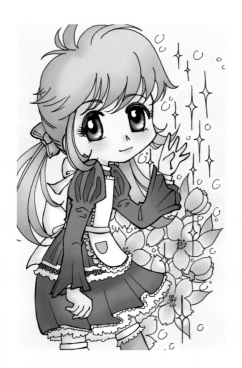

Representation of children

In comics for young girls, children are represented with large eyes and a delicate manner, with sparkles and flowers signifying happiness and beauty.

Shoujo: classic and modern

The style of line art and illustration has developed and matured throughout the history of shoujo comics, with modern titles toning down many of the most notable traits. Eyes are less sparkly, yet often drawn even larger to compensate. Faces are more defined and less "flat" than in older artwork, but still remain minimal and elegant.

Classic shoujo

Modern shoujo

SHOUJO ICONOGRAPHY

Abstract images are used heavily in shoujo-style artwork as a means of communicating emotions beyond what is literally presented. They can also help represent how a character is interpreted by other characters.

Sparkles of light

Light sparkling and reflecting throughout a scene gives the image an extra dimension of beauty and romanticism. In Shoujo, this is given greater emotional impact and depth by drawing sparkles or stars in the characters' large eyes to represent hope, happiness or longing.

Flowers

Flowers are a classic metaphor for beauty, romance and the blossoming of hope and potential. The use of flowers around characters emphasizes their charm and splendour, and often the way other characters interpret them.

Cherry blossoms

Spring cherry blossoms, known as *sakura* in Japan, symbolize springtime romance, whereas the falling of blossoms represents the end of romance, or even death.

Feathers

Feathers relate to Western images of angels and angel wings, which in shoujo titles often represent pure and idyllic elegance, with a suggestion of mortality. Characters surrounded by feathers are often serious, melancholy or unfairly misunderstood.

Shounen

The first manga stories were targeted at boys. So what are the key elements of artwork designed to appeal to a young male audience, and how do you produce it yourself?

Shounen is the Japanese word for "boy", and the term *shounen manga* refers to comics produced specifically for young males. Most of the first manga was written for boys, and it wasn't until several years later that the medium developed to appeal to a wider audience.

Much like shoujo, shounen isn't strictly a genre. The term refers to the demographic, but it also describes the styles of artwork used for these titles.

The central role

Central characters in shounen manga are almost always male – female protagonists are granted masculine roles and usually wield guns and kung fu skills, and wear tight outfits. There are usually two types of male characters: those who are painfully average, and those who have great skills. Although the skilled characters have obvious heroic roles, it's the unskilled characters that tend to offer the more interesting storylines. A relatively ordinary male character will be flung into a world where he is immediately granted something desirable – a beautiful girl, a giant robot to pilot or some form of amazing latent power. Such themes are common and effective forms of storytelling.

Action in shounen

A major aspect of shounen artwork is action and physical movement. Even stories without dynamic physical events are represented with dramatic compositions and a moving "camera". Characters face conflict, be it physical or social, and the central focus of shounen manga is the desire to accomplish a goal or overcome a major obstacle. Artists also use "speed lines" familiar from action comics, even when a character is shocked or shouting, to represent an intense and sudden emotion.

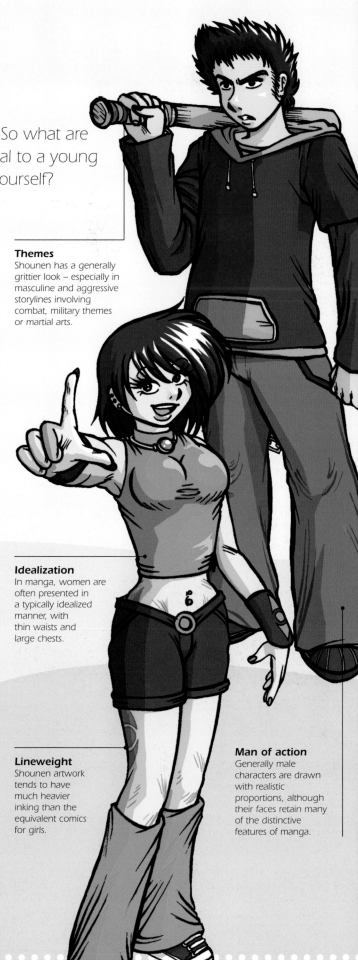

Themes
Shounen has a generally grittier look – especially in masculine and aggressive storylines involving combat, military themes or martial arts.

Idealization
In manga, women are often presented in a typically idealized manner, with thin waists and large chests.

Lineweight
Shounen artwork tends to have much heavier inking than the equivalent comics for girls.

Man of action
Generally male characters are drawn with realistic proportions, although their faces retain many of the distinctive features of manga.

See also **Action**, pages 18–19

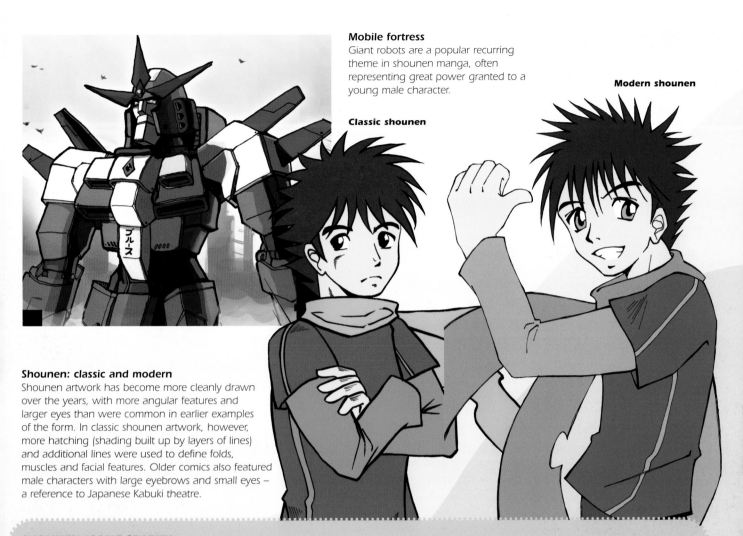

Mobile fortress
Giant robots are a popular recurring theme in shounen manga, often representing great power granted to a young male character.

Modern shounen

Classic shounen

Shounen: classic and modern

Shounen artwork has become more cleanly drawn over the years, with more angular features and larger eyes than were common in earlier examples of the form. In classic shounen artwork, however, more hatching (shading built up by layers of lines) and additional lines were used to define folds, muscles and facial features. Older comics also featured male characters with large eyebrows and small eyes – a reference to Japanese Kabuki theatre.

SHOUNEN ICONOGRAPHY

The iconography and effects used in shounen manga are far less abstract than those in shoujo artwork. They are mostly associated with realistic or outrageous expressions of power, such as fire, lightning or physical energy. Speed lines are also used to great effect in accentuating this power and adding dynamism to the overall image.

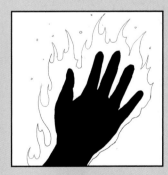

Explosions
Explosions are a simple form of imagery, yet also a hugely effective visual statement of power and movement. By using smoke, small particles and pieces of debris, you can give an explosion real energy.

Lightning
Lightning and other sparks of energy can be literal or used purely for emotional impact, as a visual metaphor for a character's rage or as an expression of shock, for example.

Speed lines
Speed lines are used extensively in shounen manga to show speed but also to express dynamism, even in scenes where emotions are the focus, rather than physical action.

Hands on fire
This is an extension of lightning imagery and other representations of energy release. Showing fire around a character, or around his limbs, demonstrates where his power and strength lie.

Fantasy and science fiction

Fantasy and science fiction are just as popular in Japan as they are in the West, yet familiar themes are filtered through the manga aesthetic to create artwork that is fresh and distinctive.

Manga stories are full of fantastic images, portraying events that are unlike anything we see in everyday life. Any story that doesn't take place either on contemporary Earth or at a predetermined point of history is a fantasy world. From Tolkienesque stories of dragons and elves to futuristic space adventures, fantasy worlds can breathe life and wonder into a story, adding – sometimes literally – another dimension.

Characters can be brought from another world, but the world they come from will define their person – and this needs to be expressed in your artwork. With consideration, it is possible to design worlds that can be the basis for dramatic or epic storylines, or serve as lavish backdrops to more modest tales.

Elven beauty
Traditional clothes and delicate features complete the look of this elven archer.

Look to the future
Bold colours and futuristic materials define the look of this space ranger.

POPULAR THEMES
The interesting stranger
A contemporary character travels through a portal and ends up in a new world. This could be through time travel, or something more elaborate. Alternatively, a character from a fantasy world comes into the real world and befriends or interacts with the other characters. In both of these instances, the character's dress and appearance should reflect the world he or she comes from. This is also a good example of a catalyst character (see Catalyst characters, pages 34–35).

Killing monsters
Monsters might take the form of evil tyrants or gigantic sea creatures, for example. If an entity is a large enough threat, gathering the strength of one or more characters to overcome it can make for a compelling and thrilling storyline. This type of story applies equally well to different worlds and to different periods in time.

See also **Creating a setting, pages 42–43**

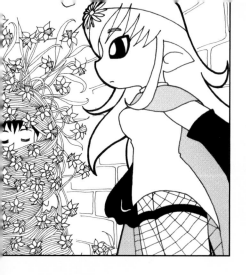

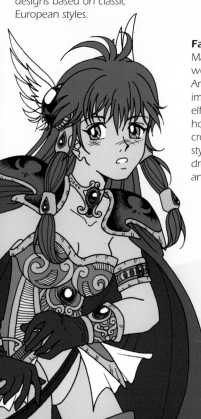

Magical worlds
Your characters can
exist in worlds of
magic and mystery.

Traditional fantasy
Highly decorative
designs based on classic
European styles.

Fantasy: classic and modern
Many of manga's classic fantasy and sci-fi designs
were heavily influenced by European, British and
American fantasy artwork, films and TV shows. These
images stuck closely to the barbarians, wizards and
elf designs popular in the West. Modern imagery,
however, often looks to find its own inspiration and
crosses modern styles and fashions with different
styles of clothing from history and different cultural
dress. This applies equally to both futuristic and
ancient characters.

Modern styles
Contemporary
fashion and
design is mixed
with classic looks.

Quests
The pursuit of something mystical, or a
journey to kill a monster, can be a great way
to take characters through strange worlds
and amazing locations. Quests have been
central to legends for centuries, and they
lend themselves particularly well to fantasy
and science fiction stories, because new
environments are equally fascinating to the
characters and to the reader.

DRAWING UPON REALITY

There is much in the real world that already
borders on fantastic, so it's often worth
exploring the wonders of our world before
seeking inspiration from elsewhere.

Many "classic" historical roles were dictated
by their environment and the society at the
time. Roles such as pirates and cowboys were
simply "jobs" that reflected the needs of the
society at the time. For example, pirates were
a consequence of the increased trade in gold
and luxury goods overseas. Roles such as
these can be reworked into different
environments with interesting results. Cowboys
and pirates have often been used in a space
flight scenario.

You may even choose to focus solely on the
visual side of things, and borrow styles and
designs from classical costumes to create your
own unique look. Try crossing over traditional
styles and designs to create something
interesting, or mixing classical looks with
modern and stylish designs. You could end up
with something really cool and distinctive.

Stories can also be set in the period in
which you take an interest, and can be either
historically accurate or simply built upon
folklore. This can give you a rich and
interesting environment to work with as well
as an established social structure, giving you
a perfect starting point for a fantastic set
of characters.

Historic influences
A cute manga rendition of an eighteenth-
century Kabuki actor from the Edo period of
Japanese history.

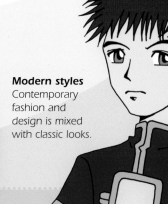

Action

Although comics are a static medium, it is possible to express great speed, swiftness and power through dynamic poses and artistic tricks.

Action stories are predominantly the mainstay of shounen manga, but most comics have dramatic moments or emotional confrontations. The appropriate use of action scenes can drive a story forward and heighten tension and drama, setting a hero apart from other characters as he or she overcomes an adversary, or is defeated only to rise again.

Flowing fabrics and long hair help to accentuate movement in action scenes.

Destruction
A breaking object, even an innocuous pair of glasses, can be presented as a dramatic event.

Reach for the sky
Jumping can be made more dynamic with the heavy use of perspective and bold composition.

SMASH!

COMMON SCENES FOR ACTION

Jumping
Jumping is a truly dynamic activity to illustrate, and offers great opportunities for stunning artwork in stories about martial arts, and also in sports manga. Jumping to make that vital basketball shot or a slow-motion dive to catch a match-winning ball represent definitive make-or-break situations for your characters. Jumping is a fantastic metaphor for personal risk taking – putting everything on the line in the hope of reward.

Car chases
The use of vehicles in a chase is always dramatic. It increases the potential for injury or even death, making the action much more exciting, dangerous and destructive (to both body and machine). Car chases are also thrilling because they are something not commonly seen in everyday life.

Falling and dropping
Dropping an important or rare item might be a significant event in your story, so it makes sense to emphasize the drama with dynamic action in your illustration. Equally, if a person falls from a fatal height the intensity is extreme, so be sure to accentuate the drama and speed of the moment.

See also **Special effects, pages 94–99**

The position of a weapon can communicate the direction of action in a scene.

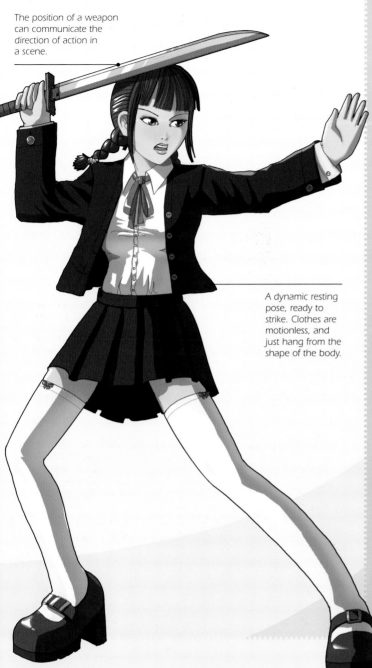

A dynamic resting pose, ready to strike. Clothes are motionless, and just hang from the shape of the body.

Running

In action manga, running is usually the result of urgency. A character is driven by a pressing desire to achieve something, facing the fear of tripping, and the threat of failure. A chase scene should convey similar emotions, including the fear of being caught.

Combat

A confrontation between two or more people, perhaps assisted by weapons or machinery, is intensely dramatic, and often the defining act of a story. Neither character wishes to lose, but both risk doing so if they make the wrong move. A closely contested battle is the most exciting, and each motion should be exaggerated or savoured in your work.

ADDING ACTION TO A SCENE

Sometimes it is necessary to make an event more dramatic. Through use of speed lines, composition and focal objects, it is possible to add tension and motion to a scene.

1.

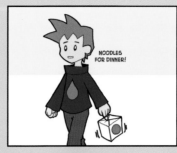

1. The character is walking down the street, carrying some food. This image has no suggestion of action.

2.

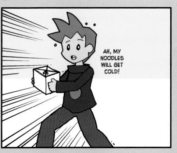

2. The character remembers that he needs to get home quickly, so he is shown to be running. Speed lines are introduced to represent the air moving quickly, and small beads of sweat are coming from his brow.

3.

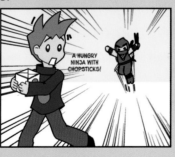

3. A ninja is chasing the character. This much greater threat, is made even more imposing by an attention-grabbing composition showing both characters moving and the relative distance between them. Speed lines have been added to highlight the areas of focus and tension.

4.

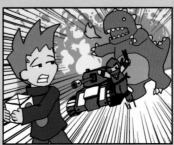

4. In this panel, another threat has been introduced in the form of a tank. The artwork has been rotated slightly to increase the tension and emphasize the horizon line. It also allows the two focal parts of the image to be drawn larger.

5.

5. However, don't go too far with your action! It is very easy to make action scenes look ridiculous, and in doing so you can spoil the tension and be left with something that feels out of place.

Comedy

However dramatic the action or emotional the scene might be in a manga story, humour has been a key ingredient throughout the history of the form.

The very earliest manga titles had a strong comedy focus, and manga has evolved to allow for ever more outrageous ways to present humour. One of the ways to do this is through exaggerating the style and understanding manga's visual grammar. Because manga is such a visual medium, it is possible to illustrate funny situations and characters without relying on dialogue.

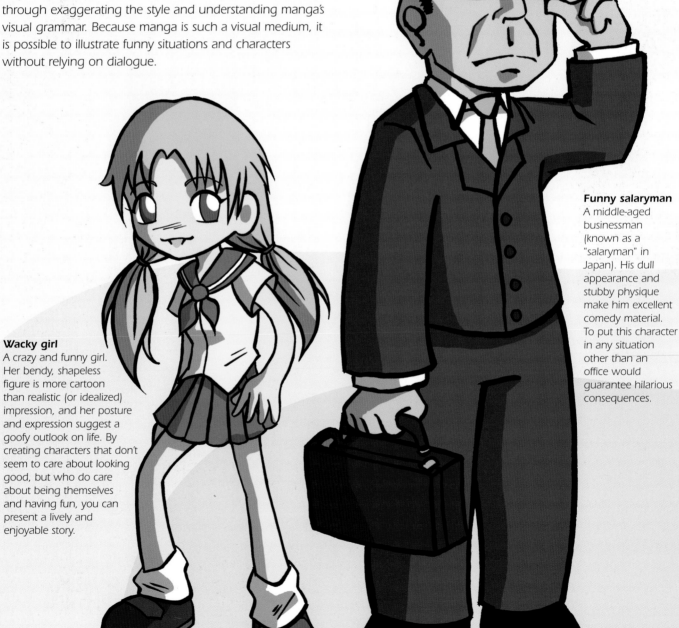

Funny salaryman
A middle-aged businessman (known as a "salaryman" in Japan). His dull appearance and stubby physique make him excellent comedy material. To put this character in any situation other than an office would guarantee hilarious consequences.

Wacky girl
A crazy and funny girl. Her bendy, shapeless figure is more cartoon than realistic (or idealized) impression, and her posture and expression suggest a goofy outlook on life. By creating characters that don't seem to care about looking good, but who do care about being themselves and having fun, you can present a lively and enjoyable story.

See also **What is manga?** pages 10–11

USING HYPERSTYLIZATION FOR COMEDIC EFFECT

Manga is a very malleable art form. Manipulating the presentation of a character or object at key moments can change our perception dramatically. For example, there are some instances when you might wish to highlight the comedic behaviour of characters in a scene. By exaggerating their form, shape, colour or style, you can introduce humour into the scene fluently – and entirely visually.

This process is known as *hyperstylization,* and is a form of visual interpretation, a subjective viewpoint, rather than a fundamental alteration of any character's design. Such exaggerated images help express characters' behaviour, as well as adding a comic flourish to your artwork.

Using different combinations of manga's visual grammar (see page 11), it is possible to detail an emotional state in an amusing and entertaining way.

Zombie gaze
This exaggerated gaze emphasizes the character's emotional state. Showing the mouth extending beyond the bottom of the face gives the impression of the mouth being open much wider than it ought to be. This is the manga equivalent of the technique used in American cartoons where someone's jaw stretches downwards to an impossible extent. In the case of manga, the visual portrayal is far less literal and plays on the two-dimensional nature of the artwork.

Wobbling limbs
Another technique is to give characters' arms and legs an almost jelly-like quality. This is often used to create the impression of a character dancing or moving in a stupid manner – usually with a blank and blissful expression – suggesting the character is oblivious to what others think of him or her.

Simple body
Reducing the shape of the limbs to a simple point makes the character look simple and cute, while also ridiculous. This is a variation of the "wobbling limbs" technique. In this instance, the character is happy, and is running around gleefully.

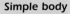

Happy floating cheeks
Using a similar technique to the mouth dropping off the face, this character has cheeks drawn so that they appear to hover away from the skin – an exaggeration, or hyperstylization, indicating a moment of extreme happiness.

CHAPTER TWO
Character creation

The key to making stories come alive is the creation of real personalities rather than mere two-dimensional drawings. Here are some examples of classic manga archetypes.

Male lead **24**

Female lead **26**

Teenage boys **28**

Teenage girls **30**

The villains **32**

Catalyst characters **34**

Children **36**

Supporting cast **38**

Costume design **40**

Creating a setting **42**

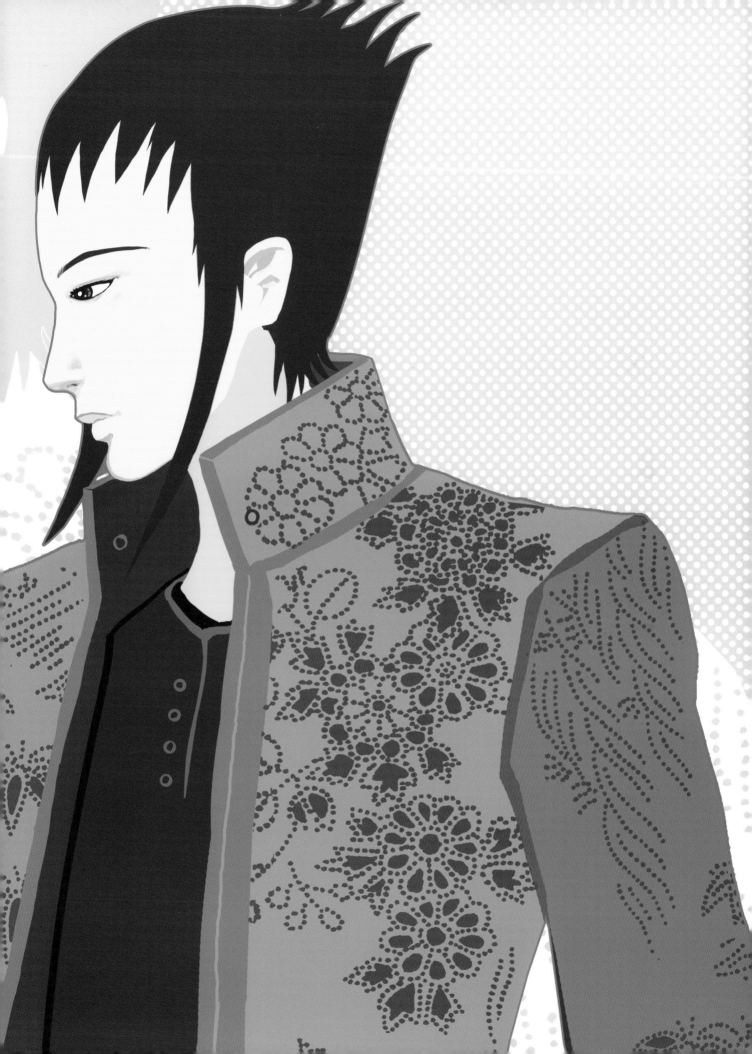

Male lead

EXAMPLE CHARACTER TYPES AND TRAITS

✳ **CONTEMPORARY MALE:** MYSTERIOUS/SLY/POWERFUL

✳ **SCI-FI MALE:** SERIOUS/STUDIOUS

✳ **FANTASY MALE:** HEROIC

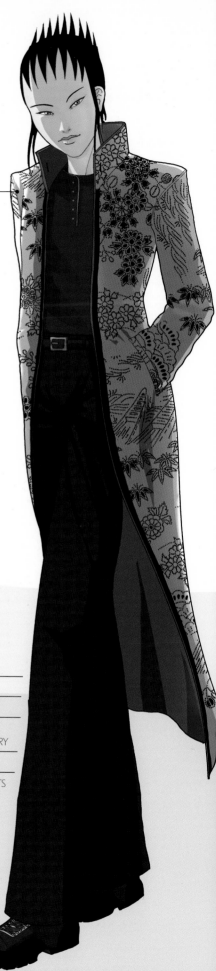

Elaborate detail or a distinctive design on clothing can help to make a character stand out.

These character types represent the fully matured male (25–30 years old). His personality is developed and his skills and abilities are established. Physically he will be at his strongest and be familiar with his own strengths, but also with his weaknesses.

The benefits of such a character to a manga story lie in his confidence and self-awareness. With such a character there is generally none of the doubt and paranoia of youth, but still enough vigour and strength to allow him an exciting storyline.

This gives you absolute freedom with regard to the roles that can be applied to him – from simpering, romantic poet to aggressive space warrior!

AVOIDING ONE-DIMENSIONAL CHARACTERS

The downside to such a character is that it is all too easy to fall into the trap of only allowing the character a single goal in the story and very little substance. The key to a successful adult male role is to remember that, despite his confidence and strengths, he is a character with a past, and this gives you real scope for character building. He, unlike teenaged or child male characters, has a history that will have shaped his outlook and behaviour. What is it that drives him? What does he hope to achieve?

CONTEMPORARY MALE

GENRE: CONTEMPORARY

CHARACTER TRAITS: MYSTERIOUS AND SLY

DESIGN FEATURES: CONTEMPORARY HAIRSTYLE; ETHNIC ORIGINS; LONG COAT SUGGESTS AIR OF MYSTERY

POSTURE: UPRIGHT, CONFIDENT

ADDITIONAL: THE CHARACTER'S EXPRESSION SUGGESTS A STREETWISE NATURE, AND PERHAPS A DARK SIDE

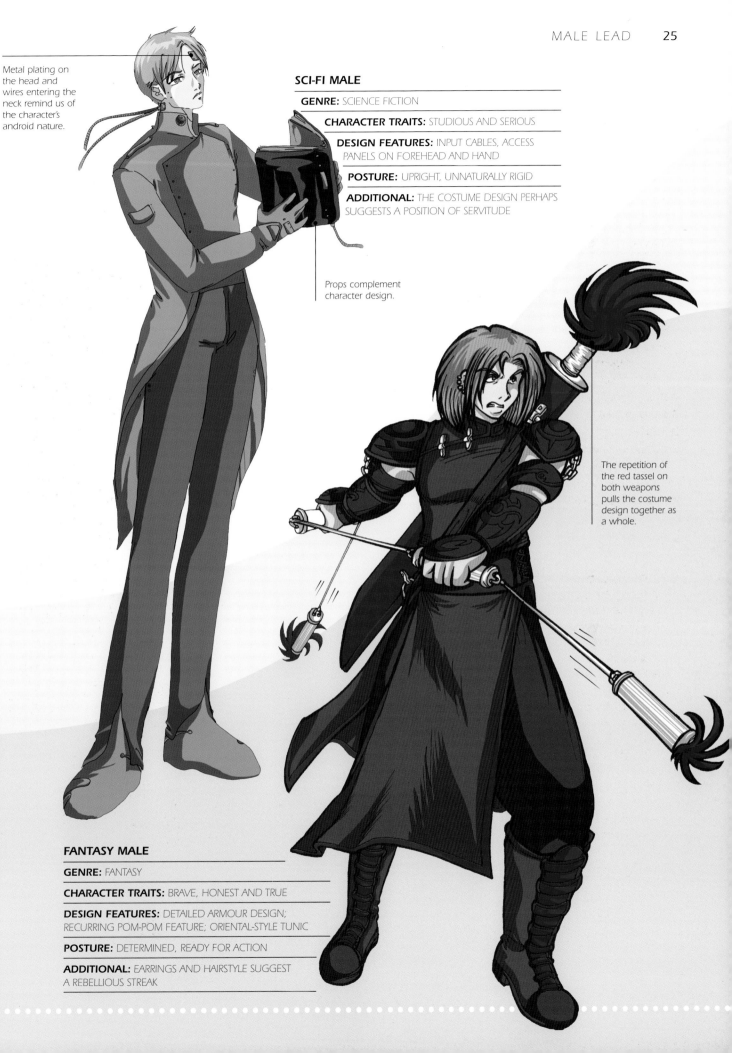

Metal plating on the head and wires entering the neck remind us of the character's android nature.

SCI-FI MALE

GENRE: SCIENCE FICTION

CHARACTER TRAITS: STUDIOUS AND SERIOUS

DESIGN FEATURES: INPUT CABLES, ACCESS PANELS ON FOREHEAD AND HAND

POSTURE: UPRIGHT, UNNATURALLY RIGID

ADDITIONAL: THE COSTUME DESIGN PERHAPS SUGGESTS A POSITION OF SERVITUDE

Props complement character design.

The repetition of the red tassel on both weapons pulls the costume design together as a whole.

FANTASY MALE

GENRE: FANTASY

CHARACTER TRAITS: BRAVE, HONEST AND TRUE

DESIGN FEATURES: DETAILED ARMOUR DESIGN; RECURRING POM-POM FEATURE; ORIENTAL-STYLE TUNIC

POSTURE: DETERMINED, READY FOR ACTION

ADDITIONAL: EARRINGS AND HAIRSTYLE SUGGEST A REBELLIOUS STREAK

Female lead

EXAMPLE CHARACTER TYPES AND TRAITS

✳ **CONTEMPORARY FEMALE:** MYSTERIOUS/CONFIDENT/POWERFUL

✳ **SCI-FI FEMALE:** SERIOUS/STUDIOUS

✳ **FANTASY FEMALE:** HEROIC/INTELLIGENT

Females in manga typically present a wider range of emotions than their male counterparts, and introduce more complex motivations. This is because their roles are often grounded more in emotional depth than in the simple resolution of problems. However, this can put the female in a position where a lesser variety of roles is available to her.

Whereas male characters are typically depicted by their strength or skill, female manga characters tend to be defined by their beauty and femininity, as well as their maternal instincts. Despite this, they are often granted relatively "masculine" roles, such as soldiers or fighters. This maximizes the potential to create fascinating, complex characters whose lives are daily conflicts between their feminine qualities and the desire to achieve in a male-dominated society. There are also plenty of possibilities to create storylines set in female-dominated societies, or in worlds where women's and men's familiar roles are reversed or mixed up.

A glass of wine gives the character a touch of class and sophistication.

CONTEMPORARY FEMALE

GENRE: CONTEMPORARY

CHARACTER TRAITS: FASHION CONSCIOUS; ATTRACTIVE AND CONFIDENT

DESIGN FEATURES: SIMPLE, CLASSIC OUTFIT; ORIENTAL HAIR ORNAMENT; LIMITED ACCESSORIES

POSTURE: OVER-THE-SHOULDER POSE; CONFIDENT, AND PERHAPS FLIRTATIOUS

ADDITIONAL: SOMETHING IN THIS CHARACTER'S POSE AND SMILE SUGGESTS THERE IS MORE TO HER THAN MEETS THE EYE

MORE THAN JUST EYE CANDY

Although it might seem generally accepted that a male manga character can rely on strength, heroism or a quirky nature to engage the reader, and the female simply needs to be beautiful, this should not be the driving force of your characters. Even a voluptuous form will seem much more attractive when the smile seems genuine and there is a real person behind it – however much attention you pay to accessories.

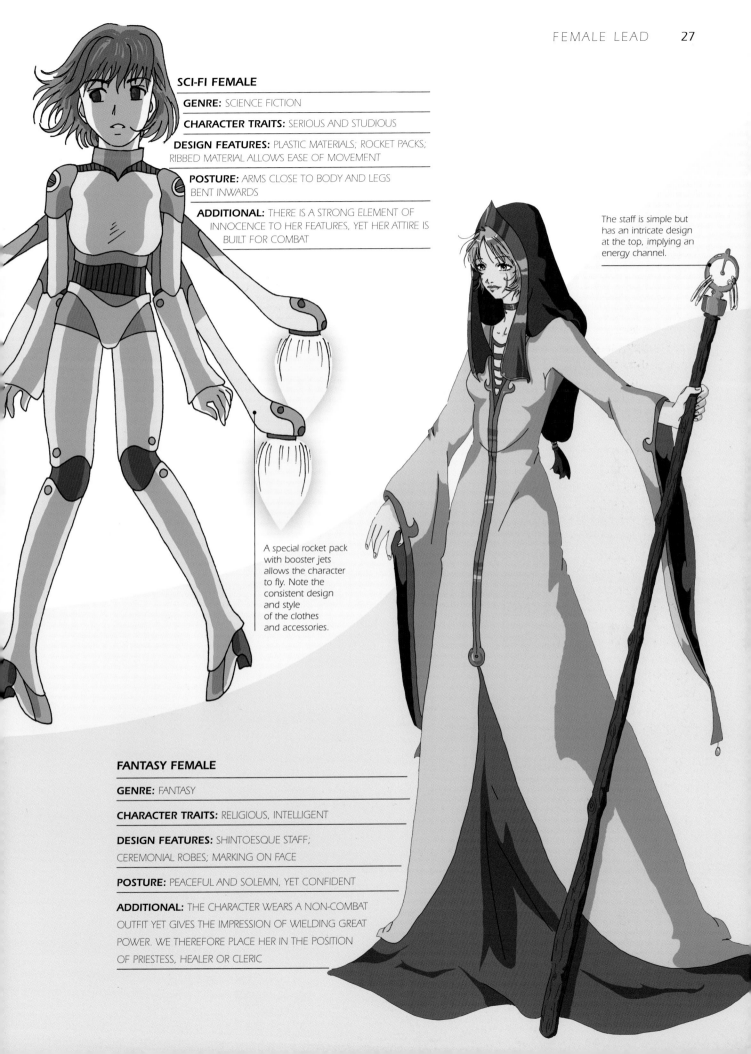

SCI-FI FEMALE

GENRE: SCIENCE FICTION

CHARACTER TRAITS: SERIOUS AND STUDIOUS

DESIGN FEATURES: PLASTIC MATERIALS; ROCKET PACKS; RIBBED MATERIAL ALLOWS EASE OF MOVEMENT

POSTURE: ARMS CLOSE TO BODY AND LEGS BENT INWARDS

ADDITIONAL: THERE IS A STRONG ELEMENT OF INNOCENCE TO HER FEATURES, YET HER ATTIRE IS BUILT FOR COMBAT

A special rocket pack with booster jets allows the character to fly. Note the consistent design and style of the clothes and accessories.

The staff is simple but has an intricate design at the top, implying an energy channel.

FANTASY FEMALE

GENRE: FANTASY

CHARACTER TRAITS: RELIGIOUS, INTELLIGENT

DESIGN FEATURES: SHINTOESQUE STAFF; CEREMONIAL ROBES; MARKING ON FACE

POSTURE: PEACEFUL AND SOLEMN, YET CONFIDENT

ADDITIONAL: THE CHARACTER WEARS A NON-COMBAT OUTFIT YET GIVES THE IMPRESSION OF WIELDING GREAT POWER. WE THEREFORE PLACE HER IN THE POSITION OF PRIESTESS, HEALER OR CLERIC

Teenage boys

EXAMPLE CHARACTER TYPES AND TRAITS

✳ **CONTEMPORARY TEENAGER:** ANGRY TEEN

✳ **SCI-FI TEENAGER:** HAPPY HERO

✳ **FANTASY TEENAGER**: MATURING TEEN

Teenagers (14–18 years old) are among the most popular protagonists in manga. Acting as a "blank canvas", a teenager is at a point where his body may have developed physically, but his mind has not yet fully matured. Teenagers are more susceptible to influences and emotions – and are in a position to act upon those feelings without an adult's responsibilities.

Male teenage characters face the trials and tribulations of manhood, but without the maturity, strength or ability of their older counterparts. They may also be portrayed as dealing with the beginnings of sexual desire. Often the result is frustration, expressing itself in a brooding and tormented nature. However, this age group also represents the point in life at which intelligence and power is first attained, and with it the beginnings of maturity and responsibility.

CONTEMPORARY TEENAGER

GENRE:
CONTEMPORARY

CHARACTER TRAITS: FRUSTRATED, ANGRY

DESIGN FEATURES:
STREETWISE DRESS SENSE; MUSIC PLAYER; FINGERLESS GLOVES

POSTURE: STRONG YET DEFENSIVE; CONFIDENT YET MISTRUSTING

ADDITIONAL: HE APPEARS COLD-NATURED BUT PERHAPS COMBATS HIS INSECURITIES WITH ANGER

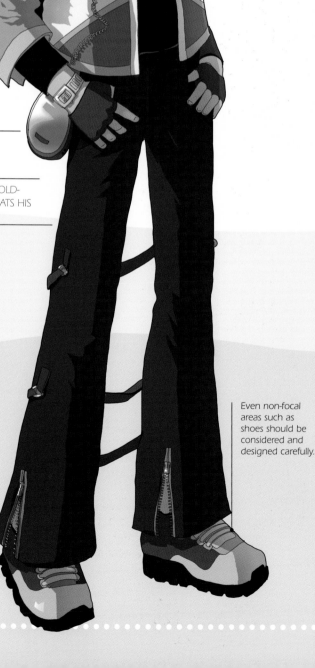

Even non-focal areas such as shoes should be considered and designed carefully.

ANTI-HERO

An anti-hero contradicts almost all of the notions of a classic hero, and yet presents a believable and interesting protagonist for a story. Teenage males are the most common form of anti-hero, as they have not yet shown the bravery or strength of the classic, heroic male. As a result, anti-heroes are often characters who are ready to attain those qualities by any means possible, or they are characters that are out of place in the world but crave the chance to demonstrate their latent qualities. Whiny, selfish or awkward teens can attain growth and self-discovery in your stories, as well as spark entertaining reactions from other characters.

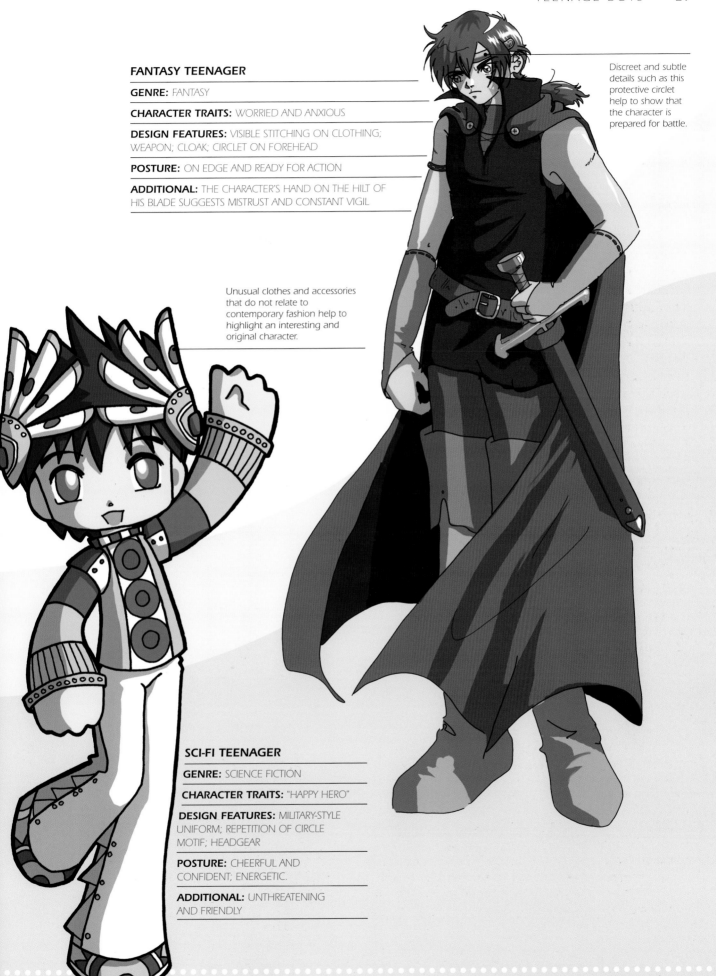

FANTASY TEENAGER

GENRE: FANTASY

CHARACTER TRAITS: WORRIED AND ANXIOUS

DESIGN FEATURES: VISIBLE STITCHING ON CLOTHING; WEAPON; CLOAK; CIRCLET ON FOREHEAD

POSTURE: ON EDGE AND READY FOR ACTION

ADDITIONAL: THE CHARACTER'S HAND ON THE HILT OF HIS BLADE SUGGESTS MISTRUST AND CONSTANT VIGIL

Discreet and subtle details such as this protective circlet help to show that the character is prepared for battle.

Unusual clothes and accessories that do not relate to contemporary fashion help to highlight an interesting and original character.

SCI-FI TEENAGER

GENRE: SCIENCE FICTION

CHARACTER TRAITS: "HAPPY HERO"

DESIGN FEATURES: MILITARY-STYLE UNIFORM; REPETITION OF CIRCLE MOTIF; HEADGEAR

POSTURE: CHEERFUL AND CONFIDENT; ENERGETIC.

ADDITIONAL: UNTHREATENING AND FRIENDLY

Teenage girls

EXAMPLE CHARACTER TYPES AND TRAITS

✴ **CONTEMPORARY TEENAGER:** CONFIDENT

✴ **SCI-FI TEENAGER:** DEMURE

✴ **FANTASY TEENAGER:** HEROIC

As with males, the female teenager (14–18 years old) is a popular choice for manga protagonist and for many of the same reasons. What sets female characters in this age group apart is how they deal with the changes and challenges with which life presents them. With females there is no apparent physical strength to solve problems; instead they come to terms with their emotions, sexual desires and preferences. As a result, the female teenager can often appear far more mature and settled than her male counterpart. There is also scope for the female equivalent of the anti-hero – though not one rooted in any male-like inner turmoil, but a character whose superior grasp of controlling emotions sets her apart.

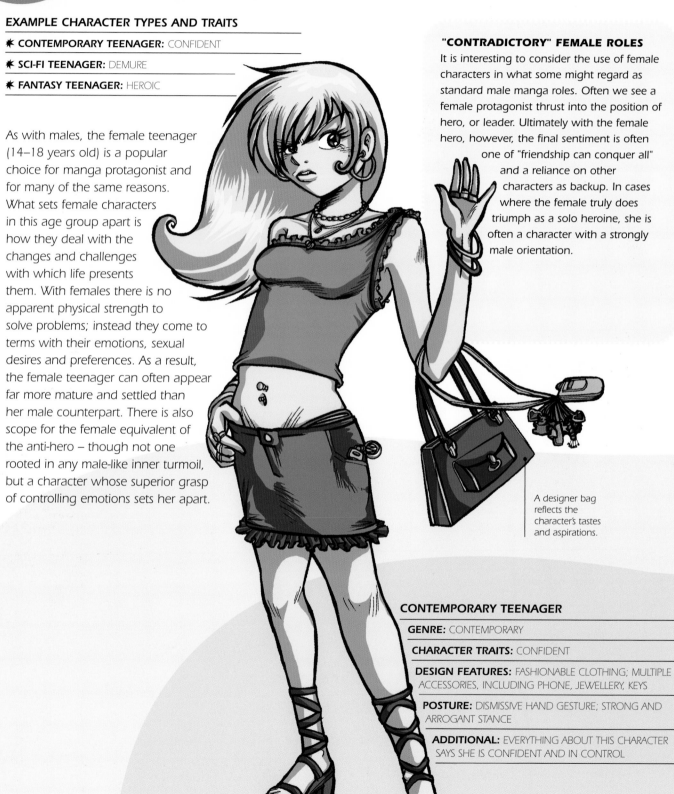

"CONTRADICTORY" FEMALE ROLES

It is interesting to consider the use of female characters in what some might regard as standard male manga roles. Often we see a female protagonist thrust into the position of hero, or leader. Ultimately with the female hero, however, the final sentiment is often one of "friendship can conquer all" and a reliance on other characters as backup. In cases where the female truly does triumph as a solo heroine, she is often a character with a strongly male orientation.

A designer bag reflects the character's tastes and aspirations.

CONTEMPORARY TEENAGER

GENRE: CONTEMPORARY

CHARACTER TRAITS: CONFIDENT

DESIGN FEATURES: FASHIONABLE CLOTHING; MULTIPLE ACCESSORIES, INCLUDING PHONE, JEWELLERY, KEYS

POSTURE: DISMISSIVE HAND GESTURE; STRONG AND ARROGANT STANCE

ADDITIONAL: EVERYTHING ABOUT THIS CHARACTER SAYS SHE IS CONFIDENT AND IN CONTROL

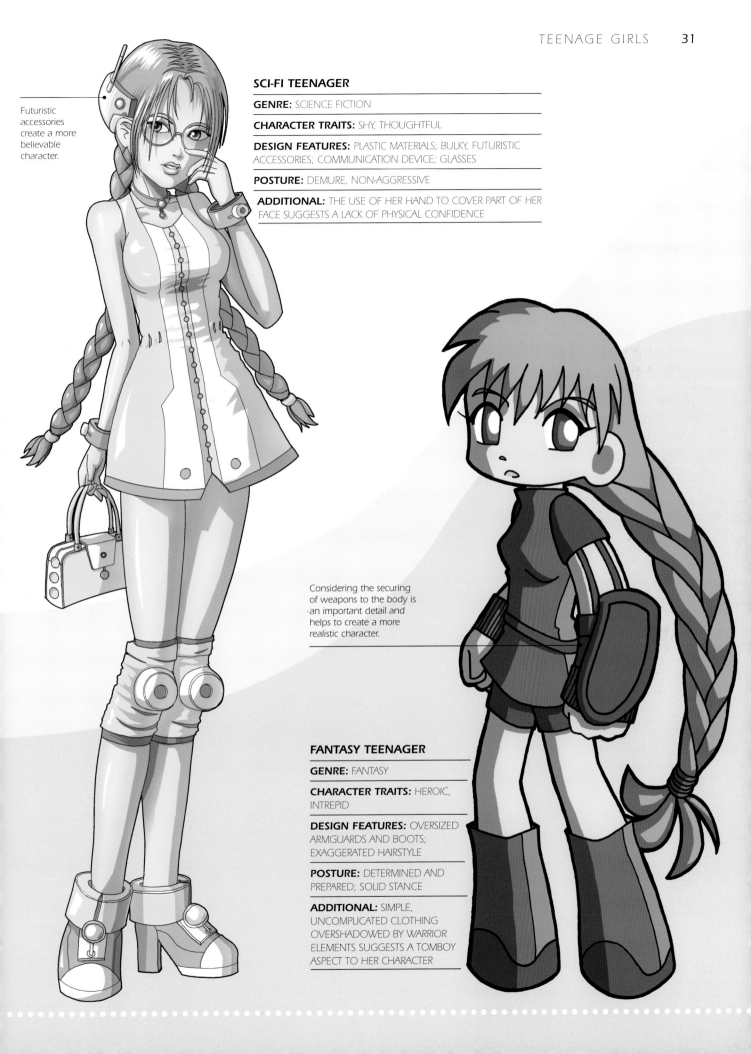

Futuristic accessories create a more believable character.

SCI-FI TEENAGER

GENRE: SCIENCE FICTION

CHARACTER TRAITS: SHY, THOUGHTFUL

DESIGN FEATURES: PLASTIC MATERIALS; BULKY, FUTURISTIC ACCESSORIES; COMMUNICATION DEVICE; GLASSES

POSTURE: DEMURE, NON-AGGRESSIVE

ADDITIONAL: THE USE OF HER HAND TO COVER PART OF HER FACE SUGGESTS A LACK OF PHYSICAL CONFIDENCE

Considering the securing of weapons to the body is an important detail and helps to create a more realistic character.

FANTASY TEENAGER

GENRE: FANTASY

CHARACTER TRAITS: HEROIC, INTREPID

DESIGN FEATURES: OVERSIZED ARMGUARDS AND BOOTS; EXAGGERATED HAIRSTYLE

POSTURE: DETERMINED AND PREPARED; SOLID STANCE

ADDITIONAL: SIMPLE, UNCOMPLICATED CLOTHING OVERSHADOWED BY WARRIOR ELEMENTS SUGGESTS A TOMBOY ASPECT TO HER CHARACTER

The villains

EXAMPLE CHARACTER TYPES

✳ **HISTORICAL VILLAIN:** ARROGANT GENTLEMAN

✳ **CONTEMPORARY VILLAIN:** CONFIDENT VAMP

✳ **SCI-FI VILLAIN:** POWERFUL GANG LEADER

✳ **FANTASY VILLAIN:** TRIBAL WARRIOR

Every protagonist needs an antagonist. Without conflict, a story cannot truly progress. All the pressure is on the bad guys of manga to act as the element of chaos – the problem that must be resolved. As a result, the bad guy is essential to the development of the hero.

Any character can become an antagonist, a threat or an opposing force given the correct circumstance and motivation – even without any of the established visual archetypes. One of the only requisites, perhaps, is the conviction that they are always right!

A successful bad guy

What makes an antagonist truly successful as a character is some element of realism and depth. In certain cases, it may be sufficient to create a bad guy whose motivation is to rule the world, but far more appealing is an antagonist with a fatal flaw, or one with a story and a seemingly valid reason for his or her actions. Empathy is the key. By creating an antagonist whose drives and ambitions can be understood and even empathized with, the reader is put into an uncomfortable position. In this way, the evil element of the story becomes far more threatening. After all, without a strong antagonist, the hero has nothing meaningful to overcome and becomes meaningless.

SCI-FI VILLAIN

GENRE: SCIENCE FICTION

DESIGN FEATURES: LONG JACKET, WHITE GLOVES, HEADBAND, RED EYES, LARGE AND POWERFUL BOOTS

POSTURE: POWERFUL AND FEARLESS

ADDITIONAL: THE GLOVES AND POSTURE OF THE CHARACTER IMPLY A ROLE OF POWER AND AUTHORITY. THE GLARING EXPRESSION AND HAND GESTURE SUGGEST FEARLESSNESS

Dramatic use of wind to lift the jacket is useful to accentuate the position of the feet. Using a light source from beneath also helps to establish atmosphere.

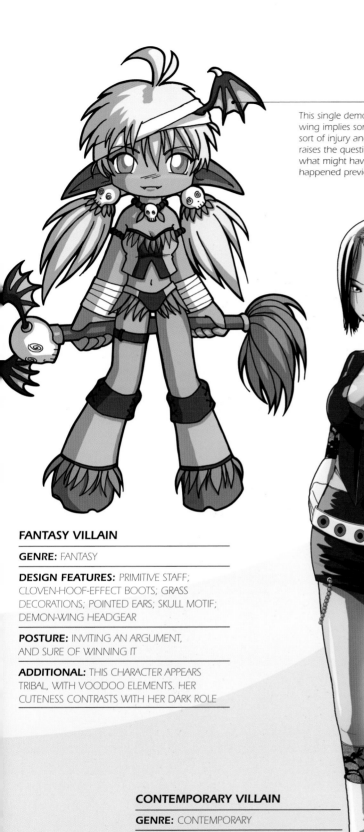

This single demon's wing implies some sort of injury and raises the question of what might have happened previously.

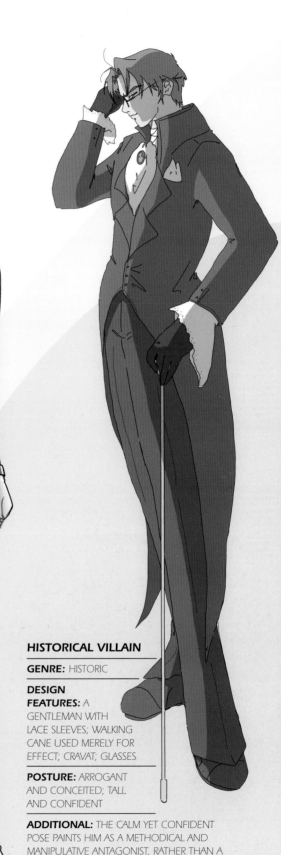

FANTASY VILLAIN

GENRE: FANTASY

DESIGN FEATURES: PRIMITIVE STAFF; CLOVEN-HOOF-EFFECT BOOTS; GRASS DECORATIONS; POINTED EARS; SKULL MOTIF; DEMON-WING HEADGEAR

POSTURE: INVITING AN ARGUMENT, AND SURE OF WINNING IT

ADDITIONAL: THIS CHARACTER APPEARS TRIBAL, WITH VOODOO ELEMENTS. HER CUTENESS CONTRASTS WITH HER DARK ROLE

CONTEMPORARY VILLAIN

GENRE: CONTEMPORARY

DESIGN FEATURES: VAMPISH OUTFIT; SLICK HAIRSTYLE; GOTHIC ELEMENT

POSTURE: CONFIDENT AND COOL

ADDITIONAL: THIS CHARACTER'S DARK ATTIRE REFLECTS HER DARK NATURE. SHE APPEARS TO BE READY FOR PHYSICAL CONFRONTATION

HISTORICAL VILLAIN

GENRE: HISTORIC

DESIGN FEATURES: A GENTLEMAN WITH LACE SLEEVES; WALKING CANE USED MERELY FOR EFFECT; CRAVAT; GLASSES

POSTURE: ARROGANT AND CONCEITED; TALL AND CONFIDENT

ADDITIONAL: THE CALM YET CONFIDENT POSE PAINTS HIM AS A METHODICAL AND MANIPULATIVE ANTAGONIST, RATHER THAN A PHYSICAL FOE

Catalyst characters

EXAMPLE CATALYST SITUATIONS OR CHARACTERS

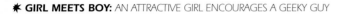

✳ **GIRL MEETS BOY:** AN ATTRACTIVE GIRL ENCOURAGES A GEEKY GUY

✳ **EVIL NEMESIS:** EVENTS ARE CAUSED BY THIS EVIL PERSON

✳ **THE FAIRY MESSENGER:** HELPS THE PROTAGONIST TO SEE PAST THEIR USUAL BEHAVIOUR

One of the simplest ways to initiate your storyline is by the use of a catalyst character. Introducing this character into your protagonist's world will kickstart a chain of events, creating a new scenario out of which you can spin an exciting plot.

The catalyst character is one who spurs the story to begin by introducing a random element that the protagonist must deal with. Depending on the form the catalyst takes, this character may also create a climate of uncertainty, forcing other characters to discover themselves at the same time as the reader discovers them. This is a far better way of exploring your characters than giving your readers a long-winded explanation of their histories.

Undoubtedly, the most notable catalysts take the form of the antagonist archetype – an enemy whose sole purpose is to set obstacles for the protagonist. However, this is not by any means the only form a catalyst can take.

It is fairly common for a manga story to revolve around an ordinary character, whose life and physical appearance are plain and unremarkable. Typically, these characters might encounter an outlandish, sexy or outrageous character who offers them a glamorous lifestyle that transforms their mundane life.

It is not always necessary to create a character, however. Sometimes the catalyst may take the form of an event – such as the protagonist's being granted great power in the form of magic abilities.

Geek meets girl
Here we see a popular catalyst situation. A young man with a quiet, possibly geeky nature finds his life turned upside down by the arrival of an attractive female character who, for some reason, feels inclined to stay with him.

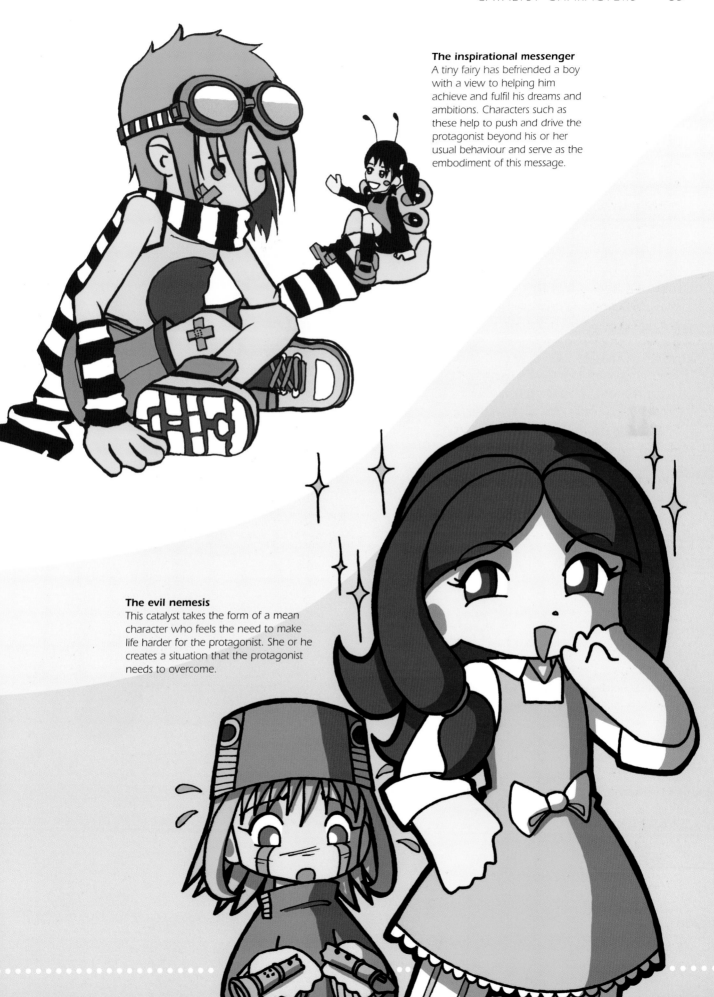

The inspirational messenger
A tiny fairy has befriended a boy with a view to helping him achieve and fulfil his dreams and ambitions. Characters such as these help to push and drive the protagonist beyond his or her usual behaviour and serve as the embodiment of this message.

The evil nemesis
This catalyst takes the form of a mean character who feels the need to make life harder for the protagonist. She or he creates a situation that the protagonist needs to overcome.

Children

Note the way in which the fire in this character's hand illuminates the whole of the illustration.

EXAMPLE CHARACTER TYPES AND TRAITS

* **ACTION BOY:** HAPPY AND CHEERFUL

* **GENKI SCHOOLGIRL:** CAREFREE AND ACTIVE

* **TRADITIONAL CHINESE BOY:** MATURE AND SERIOUS

* **MAGICAL GIRL:** MISCHIEVOUS

Manga children usually personify innocence and an undistorted outlook on life. In your story, their open-minded attitude could make a good contrast with the burdens of your adult characters. A playful child character makes a wonderful addition to many types of story, either in a supporting role or indeed, as the star.

One of the most significant things about child characters is that they seldom have concerns about love or relationships. Any focus they do have on relationships will usually centre on their friends, or (if the characters are in a supporting role) on how they relate to a parent or older sibling.

TRADITIONAL CHINESE BOY

GENRE: FANTASY

DESIGN FEATURES: COMBINATION OF ORIENTAL AND MIDDLE EASTERN TRADITIONAL DRESS SUGGESTS FANTASY SETTING; FLAME PATTERN REFLECTS MAGICAL POWERS; NOTE THE LONG PLAIT OF HAIR

POSTURE: FIGHTING POSE, READY TO ATTACK WITH FIRE

ADDITIONAL: THE CHARACTER SEEMS VERY SERIOUS, SUGGESTING HE IS MATURE BEYOND HIS YEARS

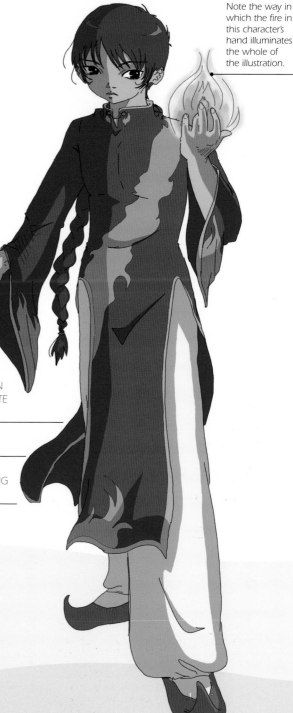

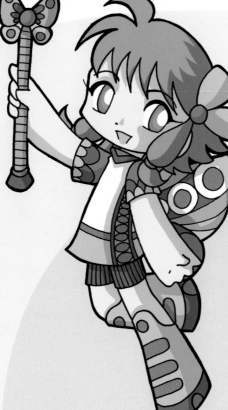

MAGICAL GIRL

GENRE: FUTURISTIC SCI-FI

DESIGN FEATURES: BUTTERFLY MOTIF; FUTURISTIC CIRCLE DESIGNS; GIRLY RIBBONS IN HAIR

POSTURE: SPRITE, FAIRY OR BALLET DANCER POSE

ADDITIONAL: THE OUTFIT AND WAND ARE ALL COORDINATED, SUGGESTING THE OUTFIT IS A COSTUME OR UNIFORM

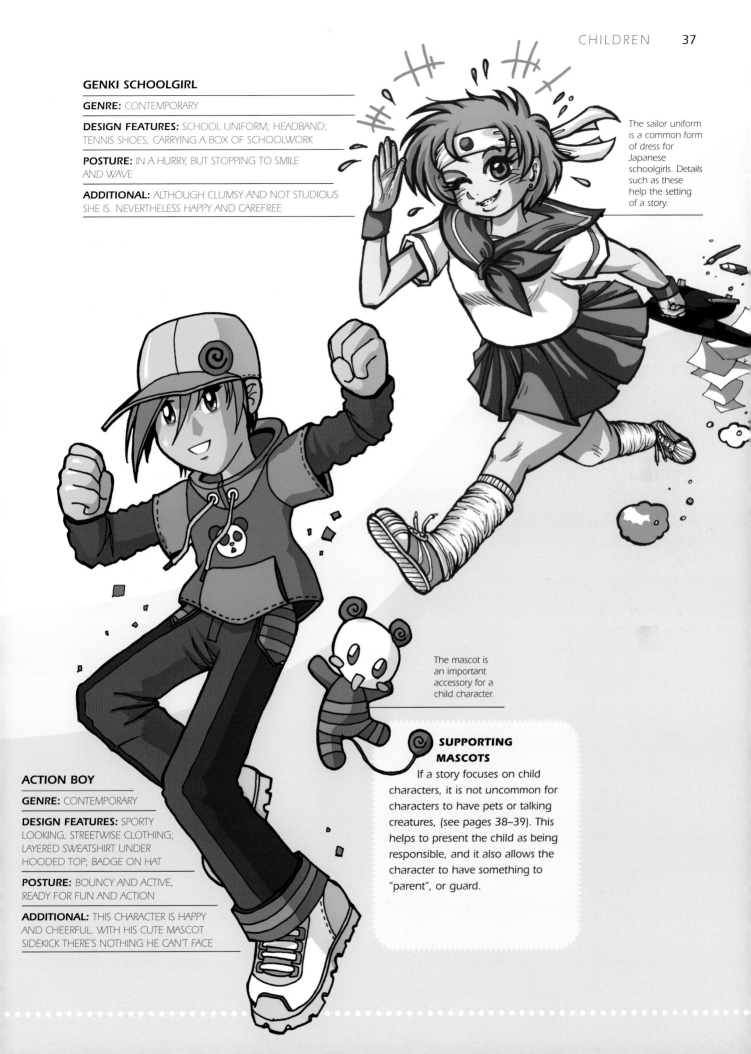

GENKI SCHOOLGIRL

GENRE: CONTEMPORARY

DESIGN FEATURES: SCHOOL UNIFORM; HEADBAND; TENNIS SHOES; CARRYING A BOX OF SCHOOLWORK

POSTURE: IN A HURRY, BUT STOPPING TO SMILE AND WAVE

ADDITIONAL: ALTHOUGH CLUMSY AND NOT STUDIOUS SHE IS. NEVERTHELESS HAPPY AND CAREFREE

The sailor uniform is a common form of dress for Japanese schoolgirls. Details such as these help the setting of a story.

ACTION BOY

GENRE: CONTEMPORARY

DESIGN FEATURES: SPORTY LOOKING, STREETWISE CLOTHING; LAYERED SWEATSHIRT UNDER HOODED TOP; BADGE ON HAT

POSTURE: BOUNCY AND ACTIVE, READY FOR FUN AND ACTION

ADDITIONAL: THIS CHARACTER IS HAPPY AND CHEERFUL. WITH HIS CUTE MASCOT SIDEKICK THERE'S NOTHING HE CAN'T FACE

The mascot is an important accessory for a child character.

SUPPORTING MASCOTS

If a story focuses on child characters, it is not uncommon for characters to have pets or talking creatures, (see pages 38–39). This helps to present the child as being responsible, and it also allows the character to have something to "parent", or guard.

Supporting cast

EXAMPLE CHARACTER TYPES

* **PIBO** (ROBOT)

* **PINKAA** (FAIRY)

* **TIGGY** (CAT)

* **KURIMI** (MONKEY)

* **ZENNI** (SQUIRREL)

* **MINIJII** (BUNNY)

It's fun to create non-human characters to act in a supporting role to the protagonist or as comic relief, and these characters are often very popular. Characters such as these also act as a vehicle for other characters to communicate their emotions and opinions – for example, by pouring out their hearts to them – avoiding the necessity for thought bubbles, or overreliance upon subtle visuals.

Supporting animals also have the ability to react to the lead characters' emotions and perhaps reflect the reader's feelings, so the reader feels he or she is watching the action alongside the magical pet. Animals also act as protective guardians, giving the character a form of additional strength or power.

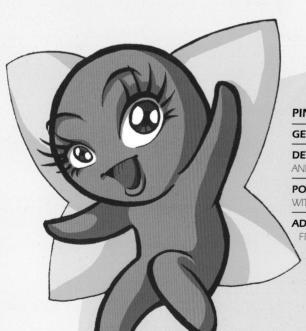

KURIMI

GENRE: CONTEMPORARY

DESIGN FEATURES: STYLIZED AND UNUSUAL-LOOKING MONKEY; SARCASTIC EXPRESSION; SIMPLE CIRCLE-BASED MARKINGS ON BODY

POSTURE: WALKS ON TWO LEGS, WITH LEGS SPREAD WIDE

ADDITIONAL: THE MONKEY'S FUNNY EXPRESSION MAKES HIM FUN TO SEE AND A GOOD ALTERNATIVE TO THE USUAL, LARGE-EYED MASCOTS

PINKAA

GENRE: MAGICAL

DESIGN FEATURES: STARLIKE AND SIMPLY SHAPED

POSTURE: HAPPY AND AGILE, WITH EXPRESSIVE LIMBS

ADDITIONAL: THE CHARACTER IS FRIENDLY AND CHEERFUL, WITH A CHILDLIKE HAPPINESS

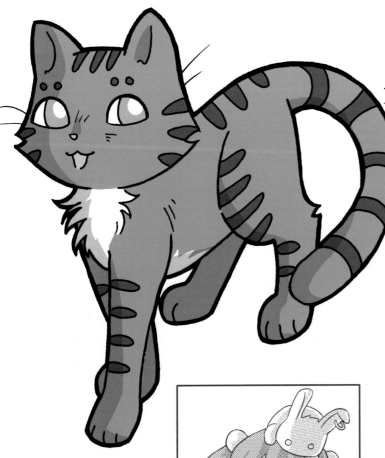

TIGGY

GENRE: CONTEMPORARY

DESIGN FEATURES: DISTINCTIVE TABBY STRIPES AND FLUFFY CHEST GIVE THIS CAT A LOT OF CHARACTER

POSTURE: WALKS NEATLY AND CAREFULLY

ADDITIONAL: THIS CAT HAS A CHEEKY EXPRESSION, AND COULD MISBEHAVE ANY SECOND

ZENNI

GENRE: MAGICAL

DESIGN FEATURES: FLUFFY FUR AND ALIENLIKE ANTENNAE

POSTURE: BOSSY AND MOODY, OBVIOUSLY LIKES TO NAG

ADDITIONAL: DESPITE BEING A NAG, THIS SQUIRREL SEEMS WISE AND THOUGHTFUL

MINIJII

GENRE: CONTEMPORARY

DESIGN FEATURES: FAT AND MALLEABLE. WEARS AN EARRING

POSTURE: USUALLY A SOFT AND LOVING POSE BUT CAN EASILY POUNCE IF ANGRY

ADDITIONAL: BY TALKING TO THIS SILENT BUNNY THE CHARACTER IS ABLE TO THINK MORE CLEARLY ABOUT HER EMOTIONS

PIBO

GENRE: FUTURE ROBOT

DESIGN FEATURES: REPETITION OF DISTINCTIVE DESIGN ASPECTS ON BELLY AND FOREHEAD, WITH EYES FOLLOWING THE SAME STYLE; JOINTS AND EDGES SHOW PLASTIC BODY CONSTRUCTION

POSTURE: SIMPLE, WITH AN EXPRESSIONLESS FACE

ADDITIONAL: THIS ROBOT IS BUILT FOR A PURPOSE, BUT CAN BECOME A GOOD FRIEND AS WELL

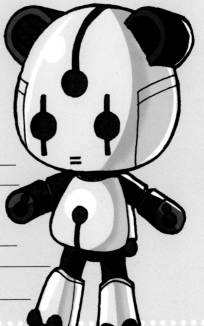

Costume design

Costume design is a major part of character creation. It communicates a great deal about a character's personality, and also the time and the culture in which they live.

A cool character needs a cool costume.

When designing futuristic or fantasy characters, try to experiment as much as possible with costume designs. Take as many influences as you can from different sources; avoid seeking inspiration solely from manga and anime. Instead, research the fashions of different cultures and centuries, even when designing the inhabitants of imagined, futuristic worlds.

Designing costumes that are reminiscent of clothing from specific eras in human history can tell your readers a great deal about the kind of future society your story is set in: in future worlds, a medieval costume might suggest a society that is still primitive in many ways, whereas military-style dress might suggest a totalitarian state. Also look at modern product design: the curves of a sports car, a gadget or a new computer might be the inspiration for part of a spacesuit, for example.

It's important to think about the detail of the costumes as well as the overall look. For instance, consider the technology available to the world in which your characters live. Simple inventions, such as zips, velcro or elastic might not be available in an ancient world of swords and sorcery. On the other hand, laces and buttons might not be necessary in a futuristic realm, as they may have developed better technologies of their own.

HINTS AND TIPS FOR COSTUME DESIGN

OLD-WORLD FANTASY

* Clothes would be sewn together more crudely, with visible stitching and simple construction.
* Consider fabrics such as silk, leather and sack cloth.
* Different colours and materials represent the class of the character. A nobleman would wear regal colours such as red or purple, and his clothing would have fine detailing.

FUTURISTIC SCIENCE FICTION

* Plastic-based fabrics and moulded plastics might be present in clothes.

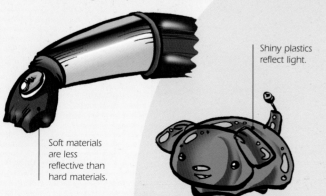

Soft materials are less reflective than hard materials.

Shiny plastics reflect light.

GENERAL

* Strings and tassels swing in the wind, and help convey motion during action.
* Long, flowing hair and cloaks have a similar effect.
* Stripes and geometrical patterns help define volume.
* When designing children's costumes, consider drawing baggy and ill-fitting clothes, as young children are still growing.
* Coordinate your design elements, especially in fantasy and science-fiction manga, as this reinforces the impression of a fully realized society.

Straight lines look flat.

Round shapes give volume.

Stripes on the character's hat and sleeves help to define the volume, as well as coordinating the costume with a consistent style.

COLOUR SCHEMES

✴ Coordinate the colours on your character with his or her costume. Defining the colours on certain sections of the costume also helps define their volume. This applies just as much to black-and-white illustration as it does to full-colour.

HAIR AND SKIN TONE

✴ If you're going to have characters that appear often in the same comic or series, it is important that you make them as different as possible at a glance. Making sure they have easily identifiable hair colours, facial features and even skin tones allows the reader to recognize the character instantly, even if not fully visible in a frame.

A simpler colour scheme is much more attractive.

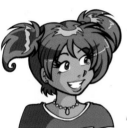

Remember to vary the skin tone of different characters.

BELTS AND BUCKLES

✴ Belts and buckles serve a practical purpose, and also show that the garment is made of fabric wrapped around your character, creating the impression of a three-dimensional person rather than a flat, 2-D image.

ZIPS AND LACES

✴ Zips can introduce detail to even the simplest garment designs.

Experiment! Using a zip as an earring creates a cool, streetwise style.

Details such as stitching enhance the look of zips.

DEFINING CHARACTER DIFFERENCES

Certain elements can be used to distinguish characters from each other. The shape of a character's facial outline, eye, nose and mouth can be very different. Hair is also commonly used to distinguish characters.

The following are examples of how shape can define a character:

Standard male chin – not pointed but not square jawed either.

Larger cheeks and pointed chin can mean a younger playful character.

In male characters a strong chin line depicts strength of character.

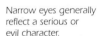

More realistically shaped eyes depict gentleness, which can be easier for the reader to relate to.

Large, elflike eyes show innocence, curiosity or sometimes intelligence.

Narrow eyes generally reflect a serious or evil character.

ACCESSORIZE!

Accessories can be used to great effect when building up a character. However, as with everything, misuse can be detrimental to your design.

It is important to bear certain elements in mind when accessorizing characters:

✴ The characters themselves: their personality, job, habitat and social grouping. For example, warriors almost certainly sport items that strengthen or protect their bodies, such as forms of armour. A specific society might demand specific accessories.

✴ The environment: how cold is the setting? Your characters may require gloves or scarves. Certain atmospheric conditions would call for specific accessories or equipment.

✴ Aesthetic: accessories are a building block of a character. The lack or addition of them can change a character's appearance as much as the clothes they are wearing. Bows, ribbons, piercings, jewellery, belts, chains and other accessories can be used to adorn a character – as long as they are appropriate.

✴ Don't overdo it! Too many accessories can detract from the strength and coherence of your design. Simplicity and practicality are the key. Also, be sure that the accessories you choose match the style.

This character is overburdened by mismatched accessories.

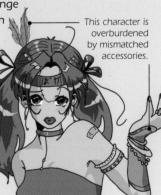

Creating a setting

The setting of your manga story is important. The universe or microcosm you create dictates the style of the characters and the mood of the story. If you plan it out properly then no world is too fantastic to be captured convincingly.

CREATING A FANTASY WORLD

A fantasy world is often dictated by the technologies available to it. Everything from communications to architecture will define the imagined culture and the physical environment. Does the culture have time travel, spaceships, steam power, electricity or even proper roads? If there are people with magical powers in your story, you have to consider whether these would be applied to practical purposes too, and what impact this might have on other parts of society. If a lot of people have a special skill, it will affect everyone. It's all about thinking through the implications of your idea.

Geography and atmosphere

What sort of environment do the characters live in? Is it a pleasant vista of fields and trees, or a series of closed cities with marauding animals in the wastelands outside? What is the weather like? An especially wet environment would affect characters' behaviour and temperament, as would a hot and arid location. Consider extreme situations too, like

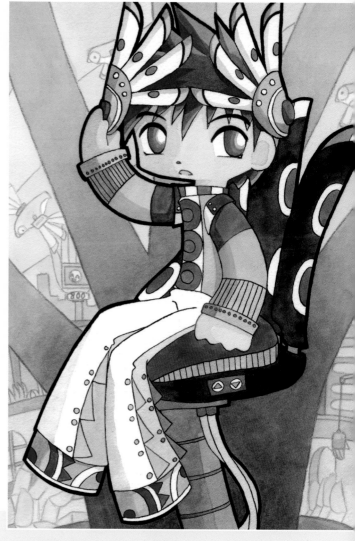

Incredible city
A futuristic environment with geometrical designs and bright colours. There are many robots based on hands.

Use of magic
Magical powers to summon the wind are used practically, to help move the boat across the water.

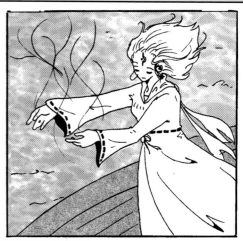

heavy pollution or toxic gas in the environment, forcing people to settle in communes or use breathing apparatus to survive.

Political and economic situations

Is the society a democracy, or a dictatorship? Are its rulers proud and noble, or evil and greedy? Consider the ways in which different types of people live their lives, and what their society is like. It isn't necessary to define every minor detail, but it helps to get a general idea of the forces that govern your characters' lives – and whether they accept them, or rise up heroically against their oppressors.

Different races and creatures

The coexistence of and relations between people or creatures is often one of great intrigue and complexity. In your manga it could be the source of a character's alienation or others' rejection of him or her through fear or misunderstanding. Alternatively, it could be a force for unity as races work together to make the most of their skills. Think also about how different races would affect the technology, the economic situation or the environment. Details such as these will help make the fantasy world seem real.

Consider gods and deities

The effects of a major overruling power could make a significant difference in the way people live their lives, and the world they live in. A world prone to floods would have houses designed in such a way that they could cope with this. If there is a need to worship or appease a god through prayer or sacrifice, this will also affect the world and its occupants.

INTRODUCING THE ENVIRONMENT

Introduce each interesting part of your scenery to the reader slowly. Focus their attention on the objects so they can learn or pay attention, realizing the significance of objects.

Even the scenery of gritty and realistic environments needs consideration.

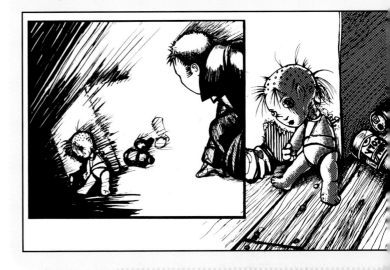

Mixing things up

You can make your fantasy world more interesting by introducing certain technologies, while removing others. For example, consider a world that has never had any fossil fuels (such as coal) but has heavy industrialization through wind power, water or solar energy. This world would have fascinating cities, with huge structures designed to make the most of the energy. Also consider the way that magic could be used as an alternative to electricity or steam power, as magic could be harnessed to produce light or heat.

OTHER PHYSICAL MARKINGS

Tattoos, birthmarks, freckles and other distinguishing marks can help identify a character. In certain situations they may also reflect the society a character is placed in. For example, in *Dragon Heir*, the citizens are branded at an early age with a "Spirit Sign", a mark that dictates their role in life.

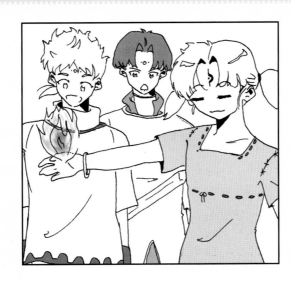

Spirit signs
Children demonstrate their special abilities, represented by the symbols on their foreheads.

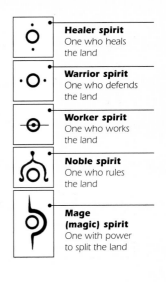

Healer spirit
One who heals the land

Warrior spirit
One who defends the land

Worker spirit
One who works the land

Noble spirit
One who rules the land

Mage (magic) spirit
One with power to split the land

CHAPTER THREE
Digital foundations

Using a computer to produce artwork can be fairly daunting at first. However, by learning some simple techniques and understanding which software to use, you'll quickly make the most of working digitally.

Peripherals **46**

All about software **48**

Photoshop basics **50**

Photoshop layers **52**

Resolution **53**

Peripherals

Having the correct tools for the job always makes a big difference in the end results, and the same goes for creating digital artwork. There are expensive, professional-quality tools available, but also plenty of options for the smaller budget.

LED OPTICAL MOUSE

You won't get very far using a graphics program without a mouse. It's highly recommended that you use a modern LED (light-emitting diode) mouse rather than a traditional ball-mechanism model. Optical mice offer greater accuracy, smoother motion and aren't prone to jamming.

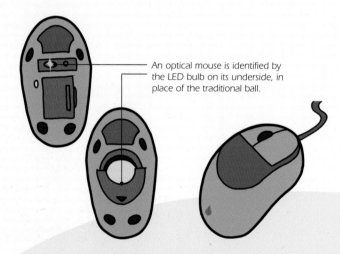

An optical mouse is identified by the LED bulb on its underside, in place of the traditional ball.

FLATBED SCANNER

A scanner is usually the digital artist's first purchase. Scanners are photocopier-like devices that interpret flat artwork and turn it into computer-readable data. These days most flatbed scanners are inexpensive, or bundled free with a new PC, and all are extremely useful for this type of work. Even a basic model is usually sufficient for scanning in line art for colouring in a software package. Pay attention to the optical resolution when buying a scanner. This will be around 600 dpi or 1200 dpi. Anything higher than 2000 is usually a fake resolution created by scaling the image.

PRINTER

Printers might seem something of a luxury for the digital artist, as often our work doesn't get printed at all and is only published on the Internet. However, it's often good to print your work – especially if it is intended for use in print – so that you can check the colours and quality.

There are several different types of printers, but two types are most common:

Laser Printer

Laser printers are excellent for text documents and printed black and white comics. The quality of the lines is very sharp, and work prints quickly. However, ink toners (refills) are expensive, and the printers themselves can require costly maintenance. There are colour laser printers available, but these too are very expensive.

Inkjet

An inkjet printer produces colour work cheaply, and quality can be high with specialist photo-paper. However, black lines aren't as crisp as those produced by laser printers, and the ink isn't waterproof, making it liable to smudging.

GRAPHICS TABLET

Most artists regard the graphics tablet as the essential peripheral for digital work. A graphics tablet is essentially a sheet of plastic that represents the shape of the monitor. Using a special pen, you "draw" on the surface, but rather than dispense ink the tip applies variable pressure, which the computer interprets and turns into an on-screen drawing. Using the pen you can use line and colour just as subtly as you would with a real pen and paper. Graphics tablets allow much greater and more natural control of the tools in all major graphics packages.

Once you get used to the tablet, you will soon be able to sketch, ink and colour your artwork entirely on the computer – without using paper at all!

TIP Graphics Tablet

Using a graphics tablet can be tough to begin with, but don't be discouraged. It's a good idea to scan in existing line art first and get used to colouring it using the tablet's pen, rather than trying to draw something freehand before getting the hang of the new system. This will help you develop your control skills.

Graphics Tablet Sizes

The size of the graphics tablet you choose can make a big difference to your overall experience of working digitally, and how comfortably you can work. Consider the size of your desk area, or whether you need to transport the tablet between different computers. If you're working with a very large monitor then a small tablet may be too inaccurate to be used easily.

The cost is almost twice as much for each increase in area size, so the larger tablets can be rather expensive. It's worth considering the tablet as a long-term investment though. A good-quality tablet will last for more than five years and still work perfectly. Some ranges also offer replacement pens and nibs.

There are also 30 cm x 46 cm (12 in. x 18 in.) size tablets available, but because of their size these are generally considered too large for comfortable illustration work.

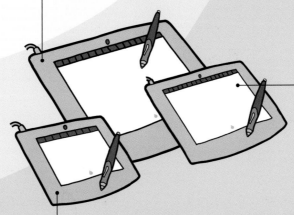

Large
23 cm x 30 cm (9 in. x 12 in.)
Larger tablets are popular choices with manga artists because they allow fine control as well as general broad strokes. However, the large footprint of these devices (often as large as 35.5 cm x 46 cm (14 in. x 18 in.) can make them impractical for small workspaces.

Medium
15 cm x 20 cm (6 in. x 8 in.)
This size gives a great trade-off between size, price and desk space, allowing good pen accuracy for a tablet that can also be easily tucked into a bag, or moved out of the way. However, some artists do still find this size too restrictive for daily use.

Small
10 cm x 13 cm (4 in. x 5 in.)
The smallest size graphics tablet is very popular and cost-effective and is ideal as a first tablet. Even if you would like to use a larger tablet later, it is worth investing in a small one first to get a feel for how a tablet is used.

All about software

Photoshop is the most popular graphics software for the majority of tasks, but there are lots of cheaper alternatives, and also more specialized tools for manga.

GENERAL GRAPHICS PACKAGES

Photoshop (Mac and PC)

Photoshop is generally regarded as the best art-generation and image-editing package. It offers a wide range of tools for originating digital artwork, plus sophisticated output controls. Photoshop is the software most commonly used for professional print work, but it also offers tools for creating images for use on the Internet. It comes bundled with a dedicated package, ImageReady, for this purpose.

Although Photoshop can seem overwhelming as a result of the large number of tools and options, it's easy to come to grips with the parts of the software that you'll use most.

Photoshop Elements (Mac and PC)

The "cut down" version of Photoshop, minus some of the more advanced features. Elements contains all the basics and is an excellent choice for getting started with digital artwork.

Pros:
A good introduction to Photoshop, its interface and features.
Cons:
Doesn't offer as many features as other budget software programs.

Paintshop Pro (PC Only)

Paintshop Pro is a popular budget alternative to Photoshop. Offering many of the same basic features, as well as some of the more advanced, it's a good alternative for those who want to save money. It doesn't provide as much control over print-oriented work, but it's still great for Internet work. If you want to get started with digital artwork, it's a great choice.

Pros:
Inexpensive; offers most of the tools from Photoshop.
Cons:
Lacks DPI (dots per inch, see page 53) and CMYK (cyan, magenta, yellow and key plate – or black) controls, which are important for print work. Runs slowly with multilayered and high-resolution images.

Pros:
Offers the widest range of tools and complete control over output resolution; is widely used and ideally suited to supplying digital work for print.
Cons:
Expensive; limited effective natural media style functionality.

DIGITAL PAINTING

Open Canvas (PC Only)

Open Canvas is the cheapest of the software listed here, and probably has the least options available. However, it offers a number of unique features, such as brush styles that smudge the paint allowing you to emulate certain types of natural media.

Pros:
Excellent brush tool creates fantastic lines and colours.
Cons:
Lacks features; brush controls are difficult; interface is awkward at times.

Pros:
The best line quality and colour blending; simulates natural media extremely well.
Cons:
Lacks basic image adjustment features; no option to disable anti-aliasing on lines. Images can't be easily manipulated for print preparation.

Painter (Mac and PC)

Painter is a highly specialized package, designed to simulate natural media such as oil paint and watercolour.

Painter offers a huge selection of brushes and has excellent brushstroke control. Despite its many wonderful features, however, Painter lacks several simple image-editing facilities and forces lines to be anti-aliased (see page 62), making manga-style screentone difficult to apply.

COMIC-MAKING SOFTWARE

Comicworks (PC Only)

Comicworks is a specialist software package from Japan, designed solely for the production of Japanese comic books. It allows you to place predefined screentone patterns onto the page and produce incredibly smooth line art. You can easily export your artwork and load it into other software, such as Photoshop, if you wish to add colour. Comicworks is an ideal choice for anyone who is dedicated to producing comics.

Pros:
Fantastic for producing print-ready line art; makes applying digital screentone easy, and prints at high quality.
Cons:
Limited to black and white artwork (no colour or grey); interface can be difficult to use.

Photoshop basics

Its origins were as an image-editing suite, but Photoshop has become the most common graphics and painting package, and the standard for both home users and industry professionals alike. Most Photoshop basics are applicable to other paint software, so what you learn here will be useful elsewhere.

KEY FEATURES OF PHOTOSHOP

Toolbar
Displays the currently selected colour and the different tools available for drawing, painting and editing the image.

Brushes Palette
Allows you to choose from different types of brushes and stroke styles.

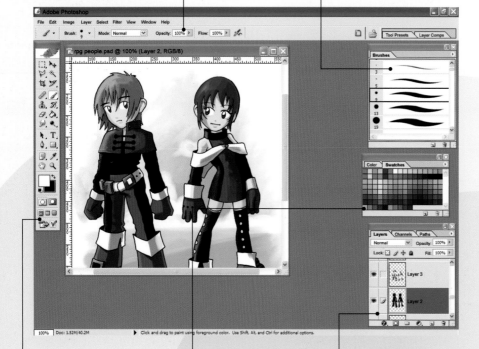

Tool Options Bar
Shows all the available options for your selected tool, allowing you to change the way the tool behaves.

Swatches Palette
Lets you pick from a palette of different colours as well as add colours of your own.

Layer Palette
Allows control of the different parts of your illustration by separating it into editable layers. (See page 52 for more information.)

USING THE TOOLBAR

Selection Tools
A selection is a part of the image that you wish to modify, either by drawing onto it or by using your selection to define an area you wish to cut and paste, edit or apply effects to. Selections are easy to use, and make work on your image much easier.

 Lasso Tools
These tools allow you to select areas of the image while allowing greater freedom in defining the shape of your selection. Use the Polygonal Lasso to define a precise area by joining points, and the Magnetic Lasso to pick up the shape of the image as you move the tool over it. The latter is of limited use in painting and illustration, but very effective in editing photographs.

 Marquee Tools
The Elliptical and Rectangular Marquee tools are used to select areas of an image defined by the shape of the tool.

 Magic Wand
The Magic Wand selects an area of the image based on the shapes and lines of the existing image. It selects an area in the same way that the Paint Bucket fills an image.

Cropping and Slicing Tools
These allow you to cut an image, either to remove elements of it or to apply information to the slices.

 Crop Tool
Used to trim the image down to a smaller size, removing unwanted parts. Marking a rectangular selection and choosing Image > Crop from the menu will achieve the same result.

 Slice Tool
For use specifically in Web site design work to separate an image into different rectangular areas, to which can be added hyperlinks.

Paint Tools
Tools that use natural media and real-world painting tools as their starting point, adding numerous editable possibilities and digital-specific effects.

 Paintbrush
The Paintbrush tool acts much like a conventional paintbrush or marker pen. It allows you to apply opaque or translucent colour and lines to the page, as you would with paint or ink.
Choosing a brush size will define the size and shape of your brush, changing the thickness and style of the lines you draw. Round brushes are most common, and will draw an ordinary line at regular thickness. Squarer and more angular brushes vary the line width when you draw in different directions, and irregular "natural media" brushes will produce a gritty, textured stroke.

The number beneath each brush indicates its diameter in pixels.

Round Brushes, Square Brushes and Natural Media Brushes

The "hardness" of the edge of the brush will define the crispness of the colour, and how much the colour fades out towards the edge of the stroke. The solid black shapes indicate hard brushes, whereas the fuzzy-looking circles represent soft edges and diffused effects.

Hard and Soft Brushes Airbrush Mode

When in Airbrush mode, holding down the mouse button (or your graphics tablet pen nib) in the same place will apply colour over itself, thickening its application. Airbrush mode can make it tricky to distribute colour uniformly. A soft-edged brush can often achieve the same results.

Opacity

This affects the translucency of your applied colour, with 100% being completely solid colour, and 0% being completely invisible. Layering semiopaque colour will thicken its effect.

Pencil Mode

 This applies colour with a sharp, pixellated edge (rather than a soft, translucent one), with no anti-aliasing (see page 62). Although this might look abrasive on-screen, it is the best way to ensure a perfectly crisp edge to your lines areas. Generally, Pencil mode is best when working at very high resolutions, if you intend to print or reduce the image later on. Working in this mode also makes it easy to select colours sampled from artwork accurately.

Healing Brush, Clone Stamp Tool and History Brush

These are custom versions of the Paintbrush for specialist uses, and are mostly useful when editing photographs.

Tolerance, Anti-Alias and All Layers

tolerance=10 tolerance=100 tolerance=200

Tolerance

This changes how similar the colour has to be for it to be considered the same colour by a selection tool. A 0 value means it has to be the exact same RGB colour, whereas 255 means that any colour will be considered the same, even black and white. Low values from 10 to 50 are usually effective enough.

all layers OFF all layers ON

 Eraser
Deletes areas of the image according to the thickness and edge of the brush size you select – effectively like the Paintbrush in reverse. If you use this on the base layer (usually labelled "Background") it will use your secondary colour.

 Paint Bucket
This will paint the currently selected colour onto the image, working in a similar manner to the Magic Wand.

Smudge, Blur and Sharpen
The Smudge tool will move colours around in the direction of the brush movement, which is useful for blending colours on hair, or for creating subtle folds in fabric. The Blur tool makes the image softer, whereas Sharpen makes it crisper by increasing the contrast of the surrounding pixels. The Unsharp Mask filter is a more sophisticated version.

Dodge, Burn and Sponge
Dodge and Burn are named after old-style darkroom photography techniques, and are used for automatic lightening and darkening of colours, respectively. The Sponge desaturates colours, making them less vibrant. Although they provide quick results, it is generally a good idea to use the Paintbrush for a greater degree of control over tone and colour.

Vector Path Tools
Advanced tools for creating curved shapes and selections that can be scaled up to any size without pixellating. These tools can be difficult to use, but create very smooth, curved areas. They are especially useful for highlights.

anti-alias OFF anti-alias ON

Anti-Alias

Checking the Anti-alias box will allow your paint (or selection) to bleed over the edge of the artwork in some areas. This can cause problems with clean line art if Tolerance is set too high, so be sure to zoom in and check your work.

All Layers

This affects whether the selection/fill is based on the artwork in the existing layer only, or whether it should consider all layers of the artwork.

 Text Tool
Use this to place text on the page. Click on the page to create a text line, and hold down the mouse button and drag to create a multiline text box with wrapping text.

 Shape Tool
Use for drawing circles, rectangles and other simple shapes. Some people prefer to use a Marquee combined with the Fill tool to achieve the same result.

 Notes Tool
Use to write hidden (non-printing) text annotations about the image.

 Eyedropper
The Eyedropper samples colour from the image and automatically changes the current colour to the newly sampled selection. This function can be achieved by holding down the Alt key when in Paintbrush mode.

 Hand Tool
Should your image be larger than the present window, this will scroll the image around. You can achieve this at all times by holding down the Space bar.

Zoom Tool
Allows you to zoom in and out of the image, making it larger or smaller onscreen. You can also use the Ctrl + [–] and Ctrl + [+] keys to do this.

Photoshop Elements

Most of the techniques applied in the tutorials on pages 66–99 can also be carried out in Photoshop Elements.

Photoshop layers

Much of the freedom of working in Photoshop comes from the Layers function. This allows you to work without damaging other parts of the drawing.

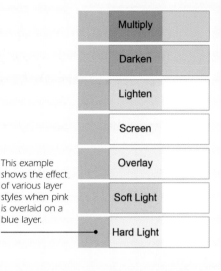

Multiply	
Darken	
Lighten	
Screen	
Overlay	
Soft Light	
Hard Light	

This example shows the effect of various layer styles when pink is overlaid on a blue layer.

Layers can be manipulated and altered easily, so your character can be made to wear a blue jacket instead of a red jacket, for example; or you can see what the image would look like with a different type of lighting. Layers are the key to working effectively with digital manga.

The best way to describe Layers is to compare the function to sheets of glass or clear plastic, like the overlays that animators and graphic designers used to use before the days of digital. When you draw and paint on a Photoshop layer, its contents are entirely independent of other layers, although the image will appear to be a single item.

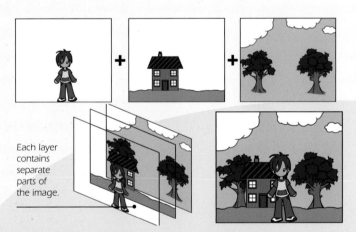

Each layer contains separate parts of the image.

Flattening Layers

Layers are only saved by Photoshop in certain file formats, so when working with the Layers function you should always save in your software package's default format – PSD in the case of Photoshop. If you Flatten the image (Layer > Flatten Image), the file size of your image will be much smaller, because Photoshop creates a single composite layer of all of the elements. This means that you lose the ability to edit the image later on. You should always try to keep an original copy of your image with Layers intact.

BENEFITS OF LAYERS

✱ Easier to add colour to lines by drawing on the layer underneath, without worrying about the details.

✱ Layers can be moved around, allowing you to alter the composition of the image freely.

✱ Parts of each layer can be deleted freely without altering other layers – making it easy to create clean, professional-quality artwork that will look great in print or on the Web.

MASKING LAYERS

A simple way to think of a mask is as a permanent selection, outside of which – or within which (depending on how you set it up) – the image is unaffected by any tool you use, or modification you make. Layer masks add a lot of flexibility to the way you can work with Layers in Photoshop, by defining how much of each layer should be visible.

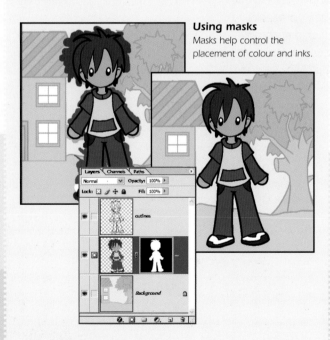

Using masks

Masks help control the placement of colour and inks.

HOW TO MASK A LAYER

1. Choose the layer, and select the area you want to be visible.
2. Click the "Mask Layer" button at the bottom of the Layer stack.
3. The layer will now be masked out and should be highlighted.
4. You can edit the layer mask with black and white brushes to alter the masked area.
5. Click back on to the main colour part of the layer to paint here as normal.
6. Right-clicking on the layer will give you the choice to disable, enable or discard the mask.

Resolution

Understanding the resolution of images is crucial when working digitally, and can help improve the quality of your work. Whether images are intended for distribution on the Web or in print, it's important to consider resolution in advance.

All digital images, be they on-screen or printed on paper, are made from dots. The more dots they have, the finer the image is. Producing images at a high resolution means more pixels (short for "picture elements", the dots used to form the image on-screen). High resolutions give you greater creative flexibility in how the final image can be used, as we will see.

Working at a high resolution puts a much greater strain on your computer. When you save files they take up more disk space, and your computer will require more memory to handle the work and a faster processor to manipulate it. The larger the image, the more data the computer has to deal with, and if there isn't enough memory available to store all that data comfortably, the computer will soon slow down or indeed be unable to load the file. Recent computers are much more capable of handling large, uncompressed graphics, but you should still invest in a decent-sized hard drive and more RAM if you intend to work on large images.

Resolution 25 dpi

Resolution 72 dpi

Resolution 150 dpi

Resolution 600 dpi

DPI

DPI stands for "dots per inch", and refers to the number of dots used to make up an image. A high-DPI image will contain more dots (and finer detail therefore) than an image with low DPI. PPI stands for "pixels per inch", which is essentially the same thing for images on-screen, but most people refer to digital colour images in terms of their DPI.

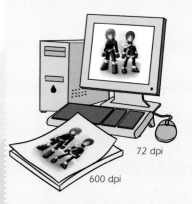

72 dpi

600 dpi

Images on a computer screen require a lower DPI count to appear smooth than images printed on paper, partially because of the way a screen is illuminated. An image printed on paper will need at least 300 dpi to appear high quality, whereas images on-screen can be as low as 72 dpi and still seem sharp. This means that an image 900 pixels wide would be 12.5 inches wide on-screen, but would only be 3 inches wide when printed at 300 dpi, or 1.5 inches at 600 dpi. Despite this, most artwork intended for display on computer is produced at a very high resolution and then later compressed. This is because working at a high resolution to begin with allows you to zoom into the image to add small details, and also gives you the freedom to use your image for either print or the Internet. When creating an illustration, work primarily with the image displayed in a "zoomed out" view, displaying the image at 50% or 25% of the actual size.

PROS AND CONS OF HIGH RESOLUTION IMAGES

Pros:
* Image can be used for print at high quality.
* Ability to add fine detail to small areas of the image.
* Minor errors become less noticeable.
* Working at a high resolution gives you the freedom to display the image at any size you wish.

Cons:
* Can lead to large file sizes on disk.
* Requires a more powerful computer to manipulate.

Minimum resolution
Low dpi images look poor when printed. 300 dpi is the minimum resolution you should work at.

GREYSCALE

FOUR COLOUR

Printers simulate colours and grey tones by using patterns of dots. Greyscale images are produced using only black ink, whereas four colours (cyan, magenta, yellow and black, otherwise known as CMYK) are used to produce colour-printed images.

See also **Scanning, pages 56–57**

CHAPTER FOUR
Digital techniques: line art

Creating high-quality line art is one of the most important steps to producing any image. Sharp, clean lines will make colouring easier and will significantly improve the presentation of your printed manga.

😫 Scanning **56**

😫 Traditional inking **58**

😫 Digital inking **60**

😫 Digital line art **62**

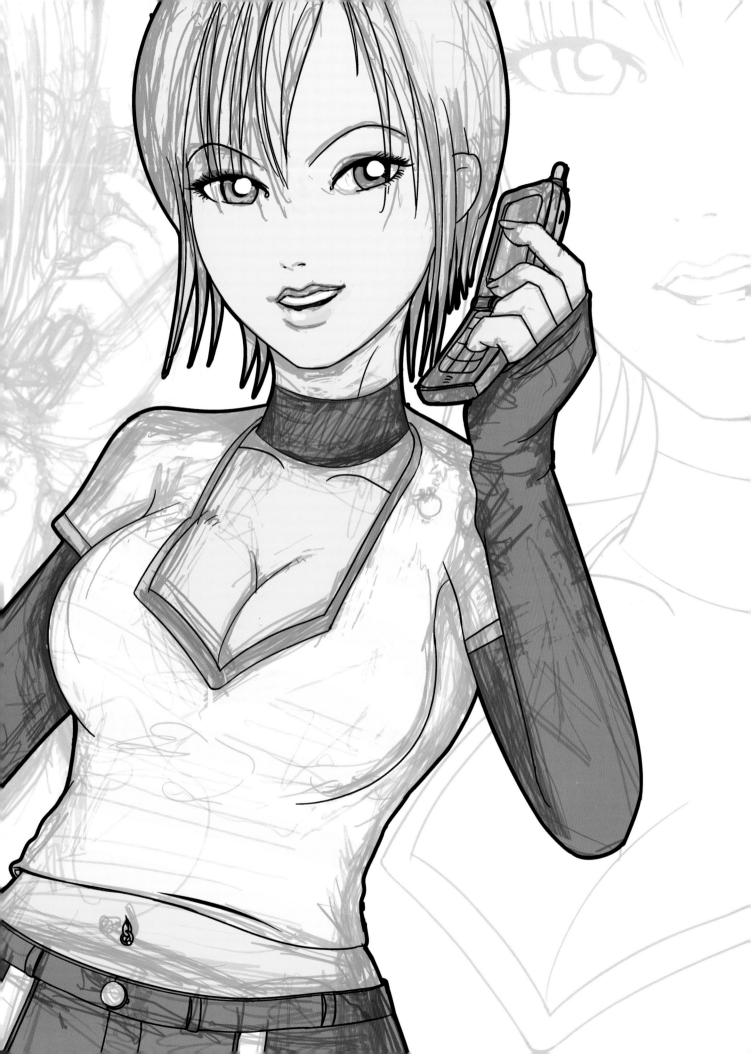

Scanning

Using a flatbed scanner allows you to take an image from paper and transfer it to computer. Such devices are inexpensive and simple to use, and enable you to enhance your illustrations with digital techniques.

SCANNING OPTIONS

Colour
This option scans the image using full colour. Useful for scanning coloured images, it is seldom necessary for scanning line art. It may be useful if you have coloured pencil lines on your page as well as ink.

Greyscale
Use the greyscale option to scan the image in shades of grey, making up 256 tones altogether. You'll probably use this most often when scanning sketches and line art.

Black and white ("line art" mode)
Using this option converts your image into pure black and white (two colours). This achieves decent results, but you can probably control the quality better by using Photoshop to convert greyscale work into black and white.

Adjust settings on your scanner before you choose "scan".

Mark out the area of the image you intend to scan with the Region Select.

Colour scan
Colour scans are slow and use more memory (RAM). They should only be used for colour images.

Greyscale
Greyscale is good for scanning pencil work or for quick results from ink.

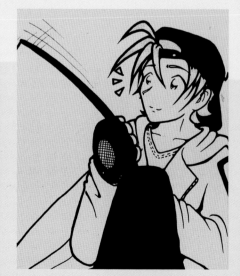

Black and white
Black and white mode is perfect for scanning ink drawings.

RESOLUTION

The most common resolution at which to scan images is 300 dpi but you can choose 600 dpi for work you intend to print or images you wish to enlarge. Very few affordable scanners can scan at much higher than 600 dpi or 1200 dpi, and attempting to scan at higher resolutions than these will do little other than freeze your machine and fill up your hard drive.

Scanning in pencil work and sketches

Pencil work can be a great starting point for a digital image. You can clean up your pencil work by increasing the contrast of the scan. Often the quality will be high enough to be used online without further modification, but generally the line quality of pencil work won't be high enough for print, except in rare instances. You can also use the Sharpen tool or Unsharp Mask filter in Photoshop to make your lines appear crisper.

Scanning in line art

Most digital artists still produce their line art on paper and then scan in the image for colouring and manipulation on computer. This tends to be the best compromise between line quality, time spent and overall image composition. You can choose whether to scan your lines in as greyscale or black and white, both of which offer their own advantages (see previous page). Setting your lines to grey can retain subtle detailing in the strokes, and is sometimes better if your line work is especially fine. However, converting your lines to black and white (whether through the scanner or in Photoshop) will give you crisper lines that have a sharper edge when printed. These will be easier to colour cleanly in Photoshop.

TIP: Splicing Images

If you have an image that is too large for the scanner, you can usually scan in several parts and then splice the image together in Photoshop. Be sure to keep the edges of the paper straight when doing this, and leave an area of overlap present on both scanned images. Create a large document, then copy and paste the two images onto the page. You can reduce the seam between the two halves by using a soft eraser (or mask) on the edge of the image on the higher level.

TIPS for Scanning

Remember you can scan straight from any graphics software by choosing the scanner from Acquire or Import in the File menu.

✳ Make sure there is no dust or eraser flecks on either your paper or your scanner bed before scanning.

✳ If you're having trouble scanning something flat, try placing books on top of the scanner lid to press it down.

✳ If there is artwork visible from the other side of thin paper ("show through"), you can reduce this by placing black card over the back of the paper.

Pencil work and sketches

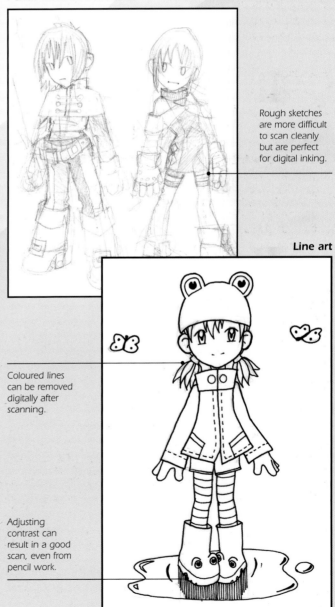

Rough sketches are more difficult to scan cleanly but are perfect for digital inking.

Line art

Coloured lines can be removed digitally after scanning.

Adjusting contrast can result in a good scan, even from pencil work.

Traditional inking

Inking is an important skill for any manga artist. For those who can't afford the expensive equipment for digital inking, or who prefer a more tactile drawing experience, traditional inking methods offer a cheap alternative.

There is always a risk of making a mistake and ruining your artwork when inking with real pens, so working on paper requires more practice and discipline than digital inking. Once you are confident controlling your pens, traditional inking offers you more control, because you can see the whole drawing at once, rather than having to zoom in to a small section as you do on computer. Even small things like the ease of rotating the page as you work make it easier to create steady lines.

Traditional inking also gives you more control over line thickness variation. Real pen lines are affected by both pressure and speed – unlike the pen of a graphics tablet, which is only sensitive to pressure.

Over the next couple of pages, we'll look at the three most commonly used tools for inking, and the pros and cons of each.

TIPS Inking

✳ Use different-sized pens according to the amount of detail you're drawing. Fine details like facial features should be drawn with finer pens than the rest of your character.

✳ If you make a mistake while inking, don't worry. Simply white out the area with correction fluid or white ink, and draw over it when it's dry.

✳ To make your inked pictures easier to scan, try drawing with non-photo pencils (whose lines are not picked up by a scanner) and inking over them. Or scan in your pencil sketch and tint it blue in your image-editing program (Photoshop, if you're using it), then print it out and use that to ink from.

✳ If the ink you use is particularly sticky, try dabbing it with a putty rubber to remove the excess after it's dried.

BRUSHES AND BRUSH PENS

Inking with a brush is actually more commonly seen in Western comics, but there are some illustrators in Japan who ink this way. Brushes give the artist a great deal of line variation, but require skill and careful control. Bear in mind that it's difficult to draw fine details with a brush, so your inked pictures may have to be larger than you're used to.

Brushes and brush pens can create some interesting lines depending on the speed at which you draw. Slow, careful strokes produce clean lines, whereas quick, loose strokes leave the texture of the bristle. These soft, textured lines are great for drawing hair or anything with a feathered texture or edge.

In terms of convenience, a brush pen is better than a brush, and is less messy. Brush pens often take ink cartridges, so you don't have to worry about the brush drying or being ruined by sticky ink. Pens with a bristle tip give the sharpest lines and have the greatest flexibility. Fibre-tipped brush pens are more suited to colouring rather than inking, as their tips are less fine and tend to blunt more easily.

FINELINERS

Fineliners are great for creating flat, consistent lines. There is no line width variation with pressure (in fact, don't press too hard – you could break the tip!), and little variation with the speed at which you draw. The consistency of line is useful if you're creating a cel-style coloured image (see pages 70–73), but it's not the best type of pen for manga – unless you use several thicknesses of pens and layer your lines to create variation and depth.

Fineliners come in two types: cheaper, disposable pens with plastic tips, and expensive metal-tipped models. Metal-tipped pens are refillable with a variety of different inks, but they require careful maintenance and cleaning (sometimes with expensive kits). The stiffness of the tips makes them difficult to use, as the ink only flows properly when the pen is held at a 90-degree angle from the page. Plastic-tipped fineliners cope better with more comfortable angles. There are lots of different brands available, each with different ink qualities and tip strengths.

TIP Varying Line Width

To vary line width with a fineliner, you need a different technique than the method you use with nibs and brushes. Because of the lack of flexibility in the tip, the only way to vary the lines is by drawing over them a few times. Drawing quickly, in a way similar to how you would build up lines on a pencil sketch, creates a more natural-looking image.

NIBS

Nibs are the traditional inking choice of manga artists. Nibs come in a range of different shapes and sizes, each with a different purpose. Wide, pointed nibs are good for drawing most things, with a smaller, firmer-pointed nib used for details and finer lines. Square-tipped nibs intended for calligraphy are rarely used.

You can easily create interesting-looking lines with nib pens with just a little practice. However, nibs can be messy and are liable to cause inkblots on your artwork. Ink also takes a while to dry, so you have to make sure you don't smudge your work as you draw. Nibs need to be thoroughly cleaned and, although they are inexpensive, they do need to be replaced frequently.

PENS TO AVOID

Biro

Biros create a soft line similar to pencils. This makes them acceptable for the occasional sketch, but a finished piece will look scruffy compared to one inked with a pen intended for drawing.

Gel pens

These are similar to biros, but stickier. The ball in the tip is easily clogged by ink, leading to broken lines. This sticky ink also makes the lines it produces smudgy and slow to dry.

Pencils

Skipping the inking stage and scanning your pencil sketch instead might seem like a time-saving tip, but really it takes just as long to clean pencil lines as it does to ink a picture. Pencil has more texture than ink, but lacks crispness. Use pencils if you want that effect, but don't think of them as a replacement for inking.

Digital inking

Thanks to graphics tablets becoming less expensive and more widely available, it is now practical to produce line drawings entirely on a computer. Drawing digitally gives you a lot more freedom than traditional inking does, but you will need a lot of practice with your graphics tablet to become as proficient as you might be with a traditional pencil or pen.

ROTATING THE PAGE

The human wrist can only turn through so many degrees, so when holding a pen it feels more comfortable and natural to draw certain angles and strokes of lines than others, especially at larger sizes. For example, it is easy to draw a small circle comfortably, as all the movement is in your hand and fingers. However, when drawing a circle larger than a couple of inches in diameter, you will find that the part of the circle closest to you will be the least comfortable to draw.

A graphics tablet (or mouse) is operated in alignment with your screen, and you will be sitting at a desk with the graphics tablet in front of you, so you'll find there are physical limitations to what you can comfortably achieve. There are ways to reduce the problem, however.

In Photoshop (and most other packages), you can rotate the image by 90 degrees by using the Rotate Canvas option from the Image menu. This can be a little slow, but it keeps your image intact so that you can rotate it back to the correct position without any loss of image quality. However, do not use the "Arbitrary" rotate option, as this will permanently damage your lines and lower the quality when you rotate them back into position.

Specialist packages such as Painter and Comicworks are designed more with the concept of drawing straight to the computer in mind, so they give you the option of rotating your canvas freely while you draw, making it much easier to work on.

FLIPPING THE PAGE

You can often spot flaws and errors in your artwork when you mirror it, so when drawing digitally it is worth using the "Flip Canvas Horizontal" function occasionally to see if you can spot any problems with the image. Fix them, and then flip the image back.

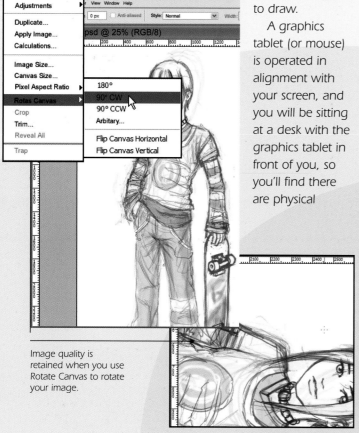

Image quality is retained when you use Rotate Canvas to rotate your image.

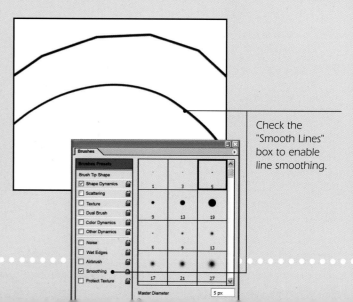

Check the "Smooth Lines" box to enable line smoothing.

See also **Traditional inking, pages 58–59**

DIGITAL SKETCHING

Computers offer a lot of flexibility with regards to how you can draw, and it's this flexibility that makes them fun to sketch with.

Experiment!

Want to try a different pose? Wondering what your character would look like carrying an item, or wearing a different outfit? Duplicate your sketch layer and hide the original, then you can draw on the new layer as much as you wish, trying out as many new ideas as you can think of.

ROTATE, SCALE AND MOVE

While you're still sketching, you can take advantage of the Image Transform tool in Photoshop. Rotating an arm, scaling a head or moving a waist might be all you need to get your image looking perfect.

Building up your sketch

Try sketching very loosely on a new layer until you get a rough version of the image or pose you want. Now, set this layer to a low opacity (30% or less), and create a new layer. Draw your image with more definition this time, using your other layer as a guide. By repeating this process you can slowly flesh out an image.

DIGITAL INKING

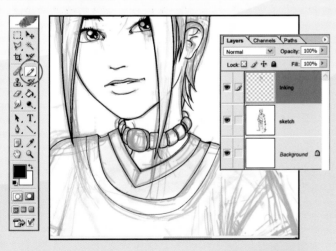

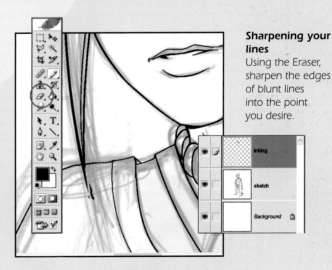

Sharpening your lines

Using the Eraser, sharpen the edges of blunt lines into the point you desire.

Creating the outline

Always work on a new layer when producing your ink outline, ideally fading your sketch to 30–50% opacity on the layer beneath. Work over the lines of your character with the Brush or Pencil tool. Sometimes it helps to turn off the sketch layer briefly to see more accurately how your lines are looking.

Drawing details on separate layers for use in colouring later

It's worth drawing folds or clothing details at this stage on a new layer. They can be used as guidelines later when it comes to colouring.

Digital line art

Preparing line art for further digital production work is an important step in every piece of artwork, and with understanding can make your work easier to produce and can give you more options in developing your images.

aliased image on screen

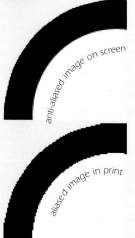

anti-aliased image on screen

aliased image in print

anti-aliased image in print

WHAT IS ANTI-ALIASING?

Everything on a computer screen is made of square pixels, so in order to represent diagonal lines and curves the screen has to arrange tiny squares in diagonal or curved patterns. With close inspection, it becomes obvious that the image is pixellated – curves in particular can look jagged on screen.

Anti-aliasing is a method that blurs the colours around the pixels in your lines to more accurately fake the appearance of a curve or diagonal. This is very effective on a computer screen and will vastly improve the overall appearance of your image. However, it is less desirable in print. The printer will try to make a pattern to represent the greys, with the overall effect that the line looks far less smooth than the "aliased" version.

Also, when using the Magic Wand and Paint Bucket tools, the computer has to begin making assumptions about correct selections and fills when it comes to working with anti-aliased images. This can lead to a loss of quality on the image.

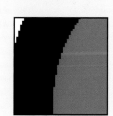

Fill tool without anti-alias

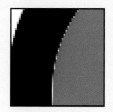

Fill tool with anti-alias

BASIC LINE ART PREPARATION: GREYSCALE LINE ART

Using a "Multiply" layer is the simplest way of setting up your line art in graphics software. This projects the black lines of the artwork over the image, and any grey parts of the image make the underlying colours darker. This method is quick to set up, and useful for most types of images. It's also great for pencil line art, or anything with distinct and crisp edges to the line work.

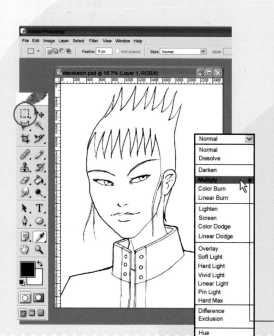

1. Background colour
Open your line art file in Photoshop. This can be either lines you have produced digitally or an image you have scanned. Specify your background colour as the colour you wish to have as a backdrop – usually this will be white at this stage.
2. Select the entire image using Ctrl + A; cut the image with Ctrl + X; then press Ctrl + V to paste the image into a new layer. Change the layer style to Multiply. This will make all white areas of the image transparent, and all black parts of the image opaque.

3. Ready to start colouring If you create another layer, located beneath the line art layer, you should be able to draw and colour without obscuring the line art at all. You're now ready to start colouring.

ADVANCED LINE ART PREPARATION: BLACK AND WHITE LINE ART

In many instances of producing digital line art, you will want your work to be as clean and "digital" as possible. This essentially requires converting the line art to black and white, and removing all white from the layer. Although this will make the edge of the line art appear "jagged" and aliased up close, it will produce the crispest line results, especially in print.

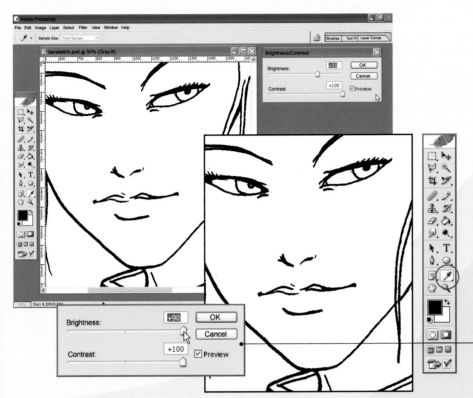

1. Open your line art file as normal, and zoom in to the lines, showing the image at 100% pixel size.

2. Select the entire image using Ctrl + A; cut the image with Ctrl + X; then hit Ctrl + V to paste the image into a new layer.

3. Use the Brightness and Contrast tool to adjust the line art to be completely black. Raise the Contrast to 100, and then adjust the Brightness until the threshold produces the desired appearance. Checking and unchecking the Preview box will allow you to see how similar the black and white lines look to the original greyscale lines.

4. Removing the white Select the Magic Wand tool, making sure "Anti-alias" and "Contiguous" are both unchecked. Select the white area of the page, and hit the delete key to delete the white area.

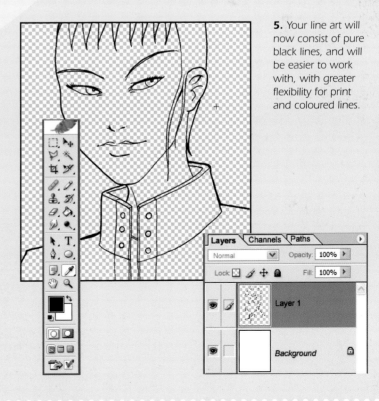

5. Your line art will now consist of pure black lines, and will be easier to work with, with greater flexibility for print and coloured lines.

See also **Scanning, pages 56–57**

CHAPTER FIVE
Digital techniques: colouring, screentone and effects

Thanks to digital colouring, it is now easy to create professional-looking work. With an understanding of the different methods you can choose the perfect style for your manga pages.

Colouring basics **66**

Cel-style colouring **70**

Airbrush-style shading **74**

Simulated natural media **78**

Lineless artwork **82**

Digital screentones **88**

Special effects **94**

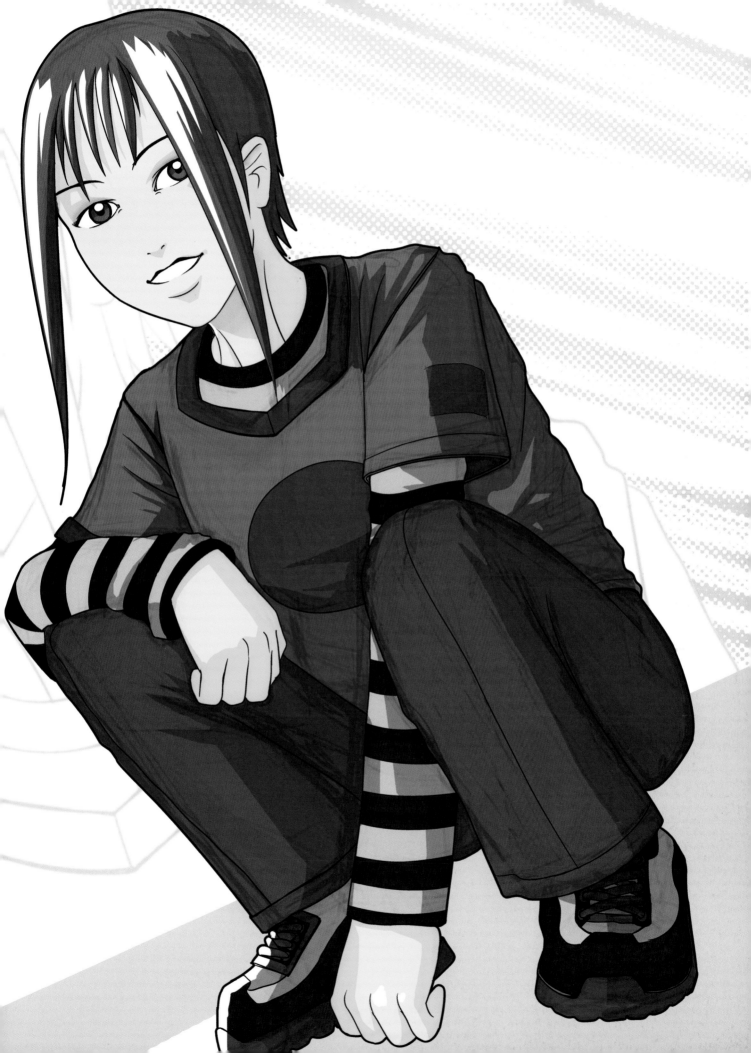

Colouring basics

No matter what kind of image you're making, you've got to start somewhere. A lot of illustrations begin with the same basic steps. Here are a few general tips that apply to most techniques.

BASE COLOURING TECHNIQUE FOR GREYSCALE OUTLINES

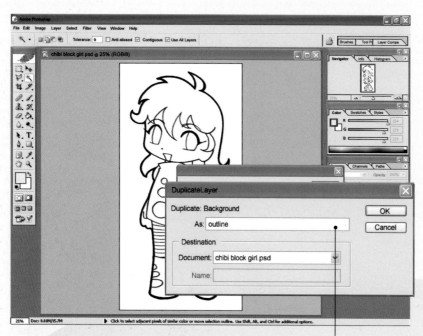

1. Set up line art layer Right-click the layer containing your inked picture and select Duplicate Layer. Name this new layer "outline", and set it to Multiply using the drop-down menu at the top of the Layer palette.

2. Create a background layer Make a new layer and fill it with any colour (light or muted tones are best). The purpose of this is to make it easier to see any gaps in your base colours later on.

 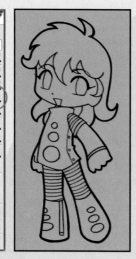

3. Create base colour layer Make another new layer for your base colours. Select an area you want to colour with the Magic Wand.

 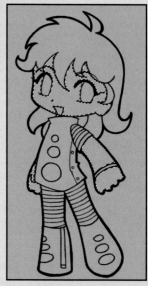

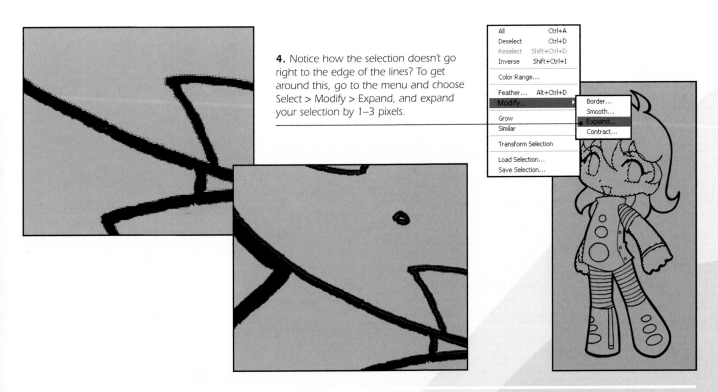

4. Notice how the selection doesn't go right to the edge of the lines? To get around this, go to the menu and choose Select > Modify > Expand, and expand your selection by 1–3 pixels.

5. Block in colours Use the Fill tool to colour the area. If you turn "Contiguous" off, you can fill the whole selection at once.

6. If there are still some areas left outside the selection, use the Polygon Lasso tool to select them manually. It's mostly small corners and sharp points that get left behind, so pay special attention to those areas.

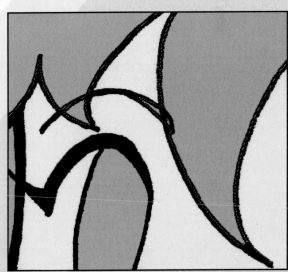

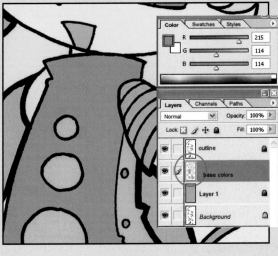

7. Where there's a lot of tight detail on the image, like the sleeve on this picture, it's quicker to use the Polygon Lasso tool to draw the selection manually as you did in the previous step, instead of painstakingly using the Magic Wand to select each bit individually.

8. Now that you've got the foundations down, you can colour the image in any style you want.

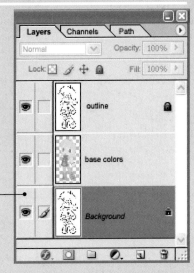

BASE COLOURING FOR BLACK AND WHITE OUTLINES

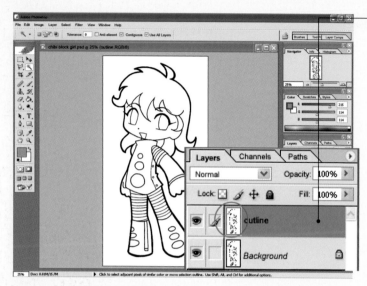

1. Create layer for line art Start by right-clicking the layer containing your inked picture and select Duplicate Layer. Name this new layer "outline".

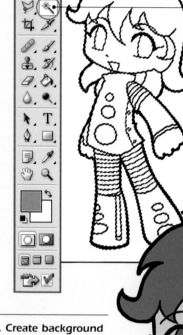

2. Remove white areas Use the Magic Wand tool, with both Anti-aliasing and Contiguous turned off, to select all the white on that layer. Hit Ctrl + X or choose Edit > Cut to remove all the white. Lock this layer.

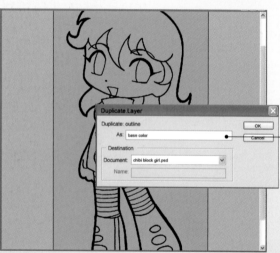

3. Create background layer Make a new layer and fill it with any colour. Duplicate the outline layer and name it "base colour", then move it below the outline layer.

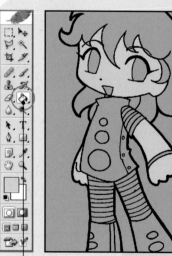

4. Block in colours Use the Fill tool, with Anti-aliasing off, to start filling in the colours.

5. If there are any small areas left behind without colour, you can simply touch them up with the Brush tool. Just use a very small brush and be careful.

6. Now that you've got the foundations down, you can colour the image in any style you want.

FIXING GAPS WHILE COLOURING

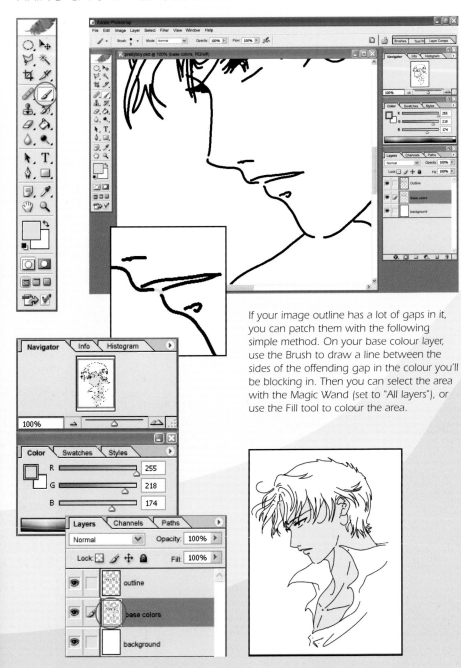

If your image outline has a lot of gaps in it, you can patch them with the following simple method. On your base colour layer, use the Brush to draw a line between the sides of the offending gap in the colour you'll be blocking in. Then you can select the area with the Magic Wand (set to "All layers"), or use the Fill tool to colour the area.

COLOURING JARGON

The colouring tutorials over the following pages will be easier to follow if you have an understanding of basic colour terms.

Hue The technical term for colours.

Shade Hues mixed with black, or other dark colours.

Saturation The intensity of a colour. A saturated hue has very pure, strong colour, whereas a desaturated hue is muted and dull.

Contrast The difference in hue or shade between two colours.

COLOUR THEORY

Your computer has millions of colours (16.7 million) from which to make a selection, so where do you start? Colour theory can help you understand the way colours are used in a composition and can help you make informed choices about your own colouring. Colour theory does not just apply to art – it's all around you. Your environment is affected by light; elements of colour theory are present everywhere.

Strong colours attract attention, so use this to create depth in your picture. Objects in the foreground should be more saturated than objects in the background. This will make the viewer focus on your characters, and create a realistic sense of perspective.

Achieving balance with colour is important too. If you want to use very bright colours you have to know which colours to use to balance them. A very bright or saturated colour on its own in a picture is jarring, but appears calmer when used with matching hues, pulling together the whole composition.

Colour and lighting

Lighting affects colour more than most people realize. It changes not only the colours of shadows and highlights, but also the colours of the whole picture. Notice how everything around you is a different colour at midday than it is at dusk? If your illustration has very strong coloured lighting, you should colour the background first and use that as a basis for your characters' colours. If you colour the character first, you might not be able to match the lighting of the character with the lighting of the environment surrounding it, leaving you with either a disjointed image or a picture with a different mood from the one you set out to achieve.

Generally, black shading should be avoided. Black drains away colour from a picture, making it seem cold and unnatural. Dark browns, blues and purples are good colours to use for shading, but mostly the choice depends on the lighting in your composition.

Cel-style colouring

Cel-style colouring refers to the animation cels used in Japanese anime, and to the technique of shading a character using a limited number of tones.

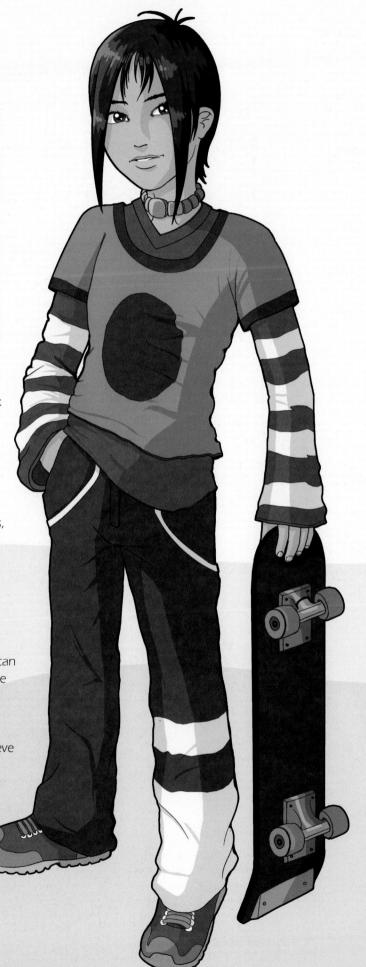

Transparent sheets of acetate are painted with bold block colours, using only a few shades to represent shadows and highlights.

The technique of creating tonal definition through the use of shadows dates back to the 1960s, with even black and white animations using the method, but it is found in some early colour pieces too. From the 1970s onwards, the vast majority of Japanese animation used this type of shading on animated characters, and the style became commonplace with anime.

In contrast, most early Western animation used no lighting or shadows on the characters at all. In the 1990s, some Western productions adopted the technique with satisfying results, but many non-CG American animation, including large-scale film productions, does without shadows on the characters completely. This is part of the reason why using cel style has become so intrinsically associated with the anime style.

It's very simple to emulate the cel-painted visual style through the use of software and digital techniques. You can change colours and control the overall look of your image easily by adjusting the layers, and you can alter your shading at will until you're completely satisfied with the results. Using your knowledge of Layers and Photoshop tools, the following steps should allow you to easily achieve an authentic cel-style look in your drawings.

CREATING A CEL-STYLE IMAGE

1. Blocking out colours Start by filling in your base colours using one of the methods detailed on pages 66–69.

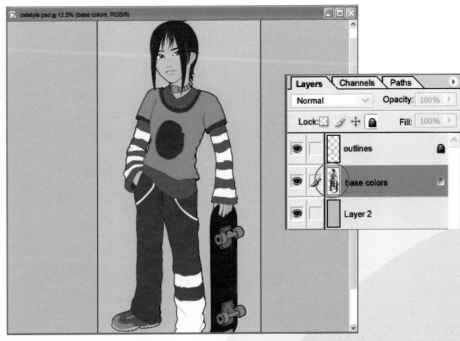

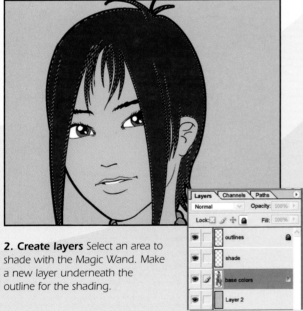

2. Create layers Select an area to shade with the Magic Wand. Make a new layer underneath the outline for the shading.

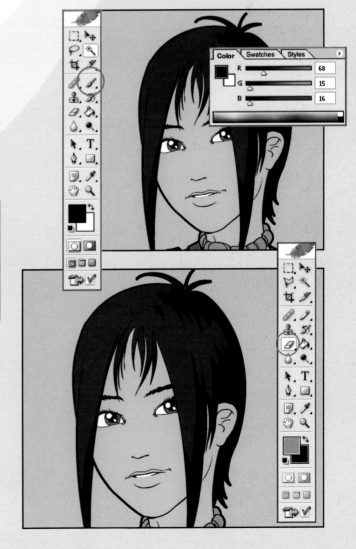

3. Block out shade and refine Loosely shade the area with the Brush tool, and then use the Eraser to smooth the lines and sharpen the points. Some parts may need more than one step of shading to give them extra depth or definition, but be sparing with your shading; adding too much will make the image look less like an authentic animation cel.

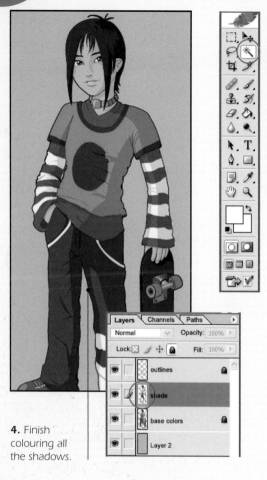

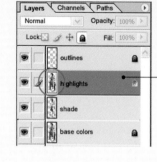

5. Highlights Make a new layer above the shading layer for the highlights. Colour the highlights in a similar manner to the shading – sparingly – and with consideration of how much light reflects off the character.

4. Finish colouring all the shadows.

Less is More

Limiting your palette may seem like a crazy thing to suggest, considering the potential of digital artwork. However, cel-style pictures benefit from minimal shading.

The shading in cel colouring is dependent on how reflective the object you're colouring is. The shinier it is, the more shadows and highlights you apply. This means it's best to use less shading on areas that are more matt, like clothing and skin, and more on areas that are shiny, such as hair and jewellery. Using fewer layers of shading will also make the image cleaner.

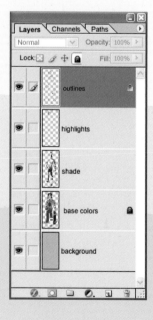

6. Your image is complete. Here you can see a breakdown of the various layers.

MATERIAL TYPES IN CEL SHADING

Skin Skin tones usually use three basic steps of colour, with a fourth additional colour sometimes used for white highlights.

Hair Hair in anime is often incredibly shiny, with at least four shades of colour, including bold white highlights.

Cloth Soft cloth absorbs light, and can be accurately portrayed with just two tones of colour.

Plastic Plastic is similar to metal, but tends not to reflect. It will use three or four shades of colour.

TIP Quick Colour Change

If you want to adjust any of the colours you've used, you can do so simply by selecting the area you want to change and going to Image > Adjustments > Hue/Saturation on the menu, or hitting Ctrl + U. Use the Hue slider to change the colour. Saturation will either fade or intensify your colours, and Lightness will fade colours out to black or white.

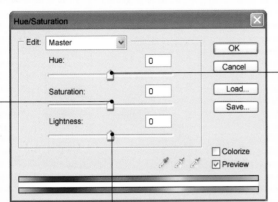

The saturation slider increases the amount of colour intensity, or reduces it to greyscale.

The Hue slider shifts the colour spectrum and adjusts all colours equally.

Increasing the lightness will mix white with the chosen colour. Reducing it will mix black.

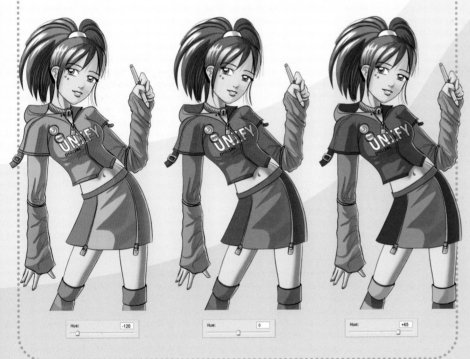

Hue: -120
Hue: 0
Hue: +65

TIP Alternative Coloured Version

The alternative colouring is achieved using the exact same techniques described on these pages. The main difference is that the artist opted for a single layer for all the shading – a bright blue colour was painted over the whole image on a layer set to Multiply. This technique gives the character consistent and dramatic lighting, but it can cause the colours to look washed out if you use an inappropriate shade. Be sure to experiment with different shades and colours to gain the best results.

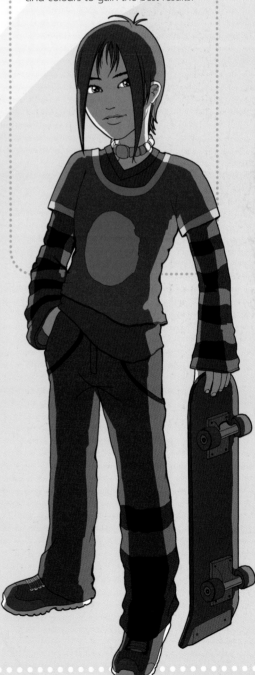

Rubber Rubber is harder than cloth, but not as hard as plastic. Use two or three shades.

Metal Different types of metal use different numbers of tones, but often metal is presented as shiny, with four colours being used. Sometimes the metal reflects objects around it, so it will pick up colours from neighbouring objects or the environment.

Airbrush-style shading

Many artists use brush tools in Photoshop to soften the appearance of their artwork, and to accentuate the volume of their characters. Digital airbrushes and other soft-edged brushes introduce subtle blending of shadows on the figure, and can help to distinguish between different types of material and surface.

CREATING AIRBRUSH-STYLE SHADING ON AN IMAGE

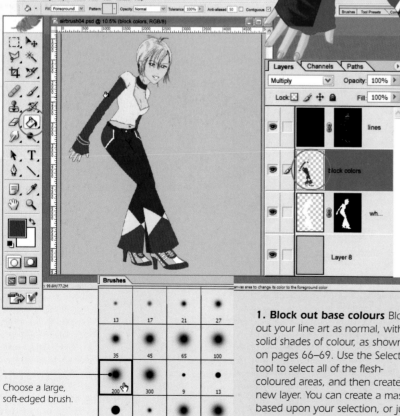

Choose a large, soft-edged brush.

1. Block out base colours Block out your line art as normal, with solid shades of colour, as shown on pages 66–69. Use the Selection tool to select all of the flesh-coloured areas, and then create a new layer. You can create a mask based upon your selection, or just keep your selection and use that as a guide.

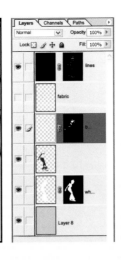
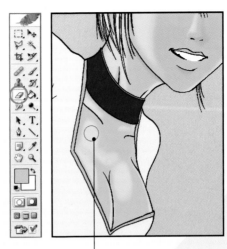
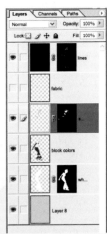

2. Soft "cel" style Choose a complementary colour tone and use a large, soft-edged brush. Mark out the lighting much as you would with cel colours, with your brush set to 100% opacity.

3. Erase highlight areas Change the Eraser tool to use a similar large soft brush, and work with both the Brush and Eraser to define the shape of the area.

4. Brush control Changing the brush size will help you control the spread of colour and the hardness of the edge. Use the [and] keys to scale the brush up and down. A small brush will have a harder edge than a large brush.

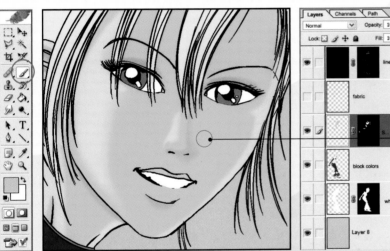
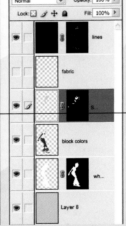

5. Define subtle shading Use a darker skin tone to add further definition and shadow beneath the neck, beneath the lips and under the nose. The shading of the skin areas is now complete, and we can move on to shade the rest of the image.

6. Create a new layer and use any obvious colour – here we've used green – as a guideline to draw folds of clothing onto the image. Bearing in mind where the fabric will pinch and gather, draw lines emanating from the point of tension.

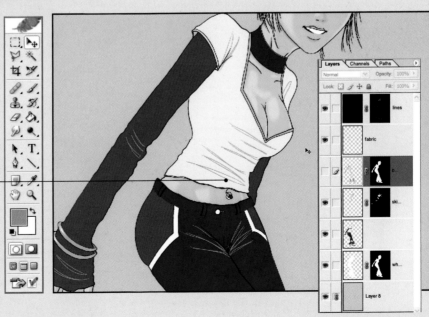

7. For the rest of the clothes, use a single layer to define shading. Create a new layer set to "Multiply" at 100% opacity. At this point, we have chosen a cream shade, which will be applied to the image as the shading tone.

8. Precision smudging Using smaller brushes will create sharper creases, whereas larger brushes will create bunched folds. Bearing in mind the shape of the character, you can define volume with these folds.

9. TIP: Grey stripes have been added to the girl's top at this point to help define volume. Remember that the curvature of stripes, lines and patterns helps to stop images from looking flat and lifeless.

10. We've used the Smudge tool to create the impression of fabric folds. Smudging the shadow outwards along the guidelines, and then smudging the shadow inwards, creates the desired effect.

11. Fine detail Create a new layer (set to "Normal") for the make-up and facial details. Add pink lipstick and eyeshadow, and lighter tones to show the light shining off the lips. Add similar details to the fingernails and belly button.

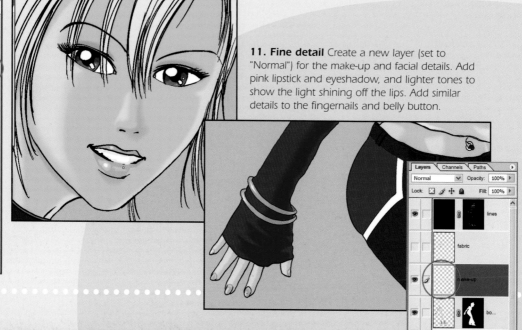

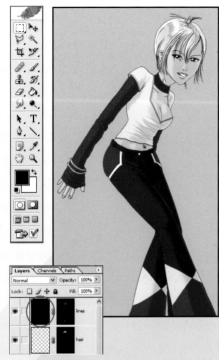

12. Smudging highlights We've created the hair with the Smudge tool in a manner similar to the folds of the fabric. To do this, place layers of colour down to define shade, and then smudge to follow the shape of the head. When you're happy with one layer of depth, introduce lighter shades and repeat the process over again to build up layers just like those of real hair.

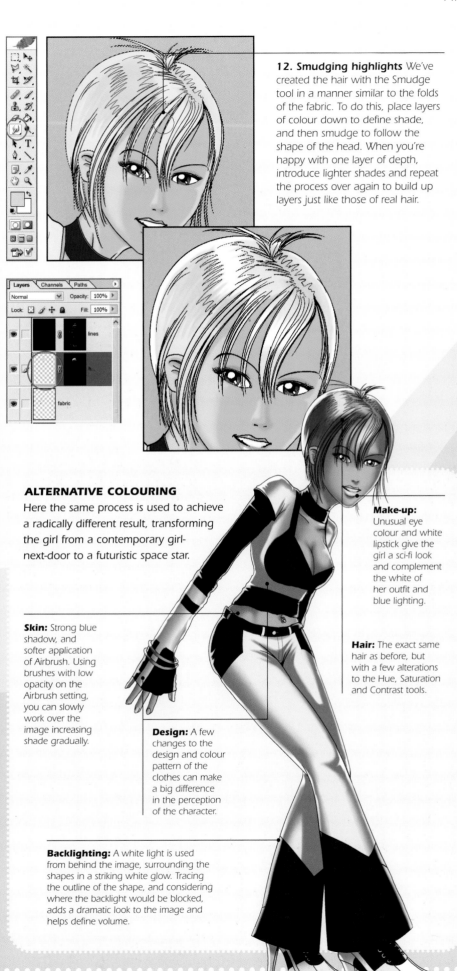

13. Coloured lines Here we've finished the image by colouring the lines in a similar manner to that described in Simulated Natural Media (see pages 78–81), selecting the black lines and colouring them on a new layer. The image is now complete.

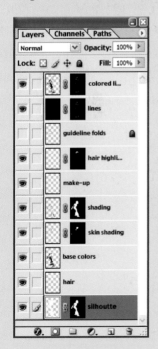

ALTERNATIVE COLOURING

Here the same process is used to achieve a radically different result, transforming the girl from a contemporary girl-next-door to a futuristic space star.

Make-up: Unusual eye colour and white lipstick give the girl a sci-fi look and complement the white of her outfit and blue lighting.

Skin: Strong blue shadow, and softer application of Airbrush. Using brushes with low opacity on the Airbrush setting, you can slowly work over the image increasing shade gradually.

Hair: The exact same hair as before, but with a few alterations to the Hue, Saturation and Contrast tools.

Design: A few changes to the design and colour pattern of the clothes can make a big difference in the perception of the character.

Backlighting: A white light is used from behind the image, surrounding the shapes in a striking white glow. Tracing the outline of the shape, and considering where the backlight would be blocked, adds a dramatic look to the image and helps define volume.

Simulated natural media

Computer-generated (CG) illustration is known for being pristine and flawless, but as computers have become more powerful and versatile, software packages have been created to make illustrations look more human, and a little less than perfect. Natural media simulators such as Painter add that little bit of "hand-made" texture.

OIL PAINT STYLE

Oil paints smear together, giving tonal areas definition yet softly blending at the edges.

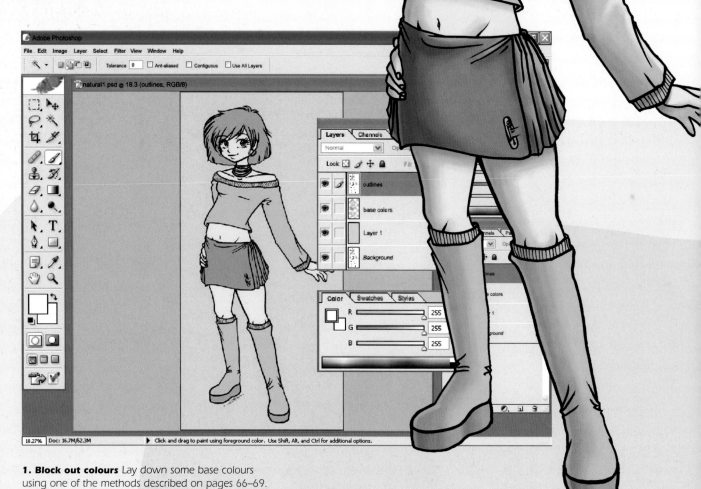

1. Block out colours Lay down some base colours using one of the methods described on pages 66–69.

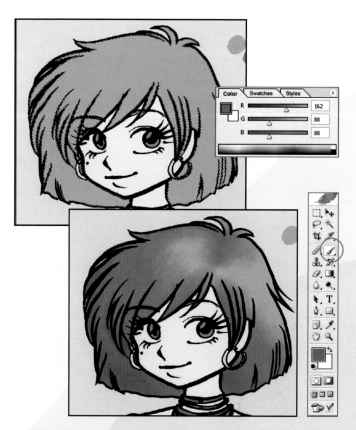

2. Set up shading layers Create a new layer for your shading. This illustration only uses one for all the shaded areas. However, you can use as few or as many as you feel comfortable with. There's a second layer for the palette to help us keep a record of the colours we've used. This is essential in natural-media-styled work, because the original shades are blended together so much they may become hard to pick out with the Eyedropper.

3. Starting to shade Select an area and start shading with the darkest shade. Here we've used an almost transparent textured brush. Between 10% and 25% opacity is recommended, depending on how dark your colours are. Notice how we're working texture into the image? Short, quick brushstrokes are used to build up colour slowly.

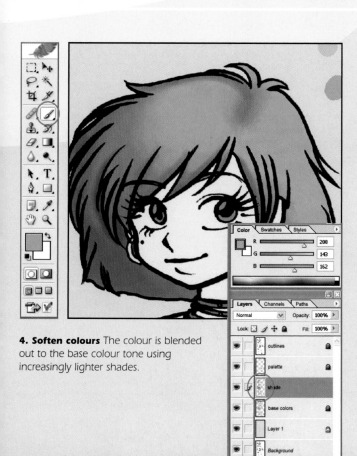

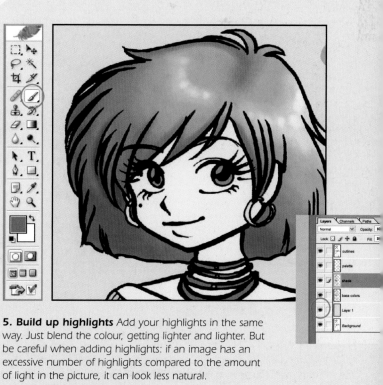

4. Soften colours The colour is blended out to the base colour tone using increasingly lighter shades.

5. Build up highlights Add your highlights in the same way. Just blend the colour, getting lighter and lighter. But be careful when adding highlights: if an image has an excessive number of highlights compared to the amount of light in the picture, it can look less natural.

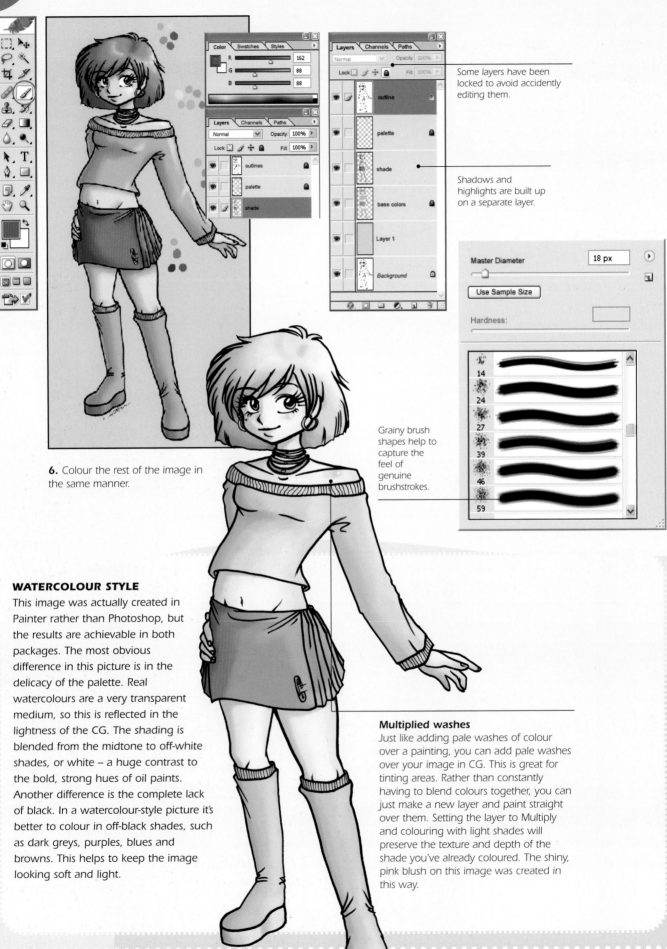

Some layers have been locked to avoid accidently editing them.

Shadows and highlights are built up on a separate layer.

Grainy brush shapes help to capture the feel of genuine brushstrokes.

6. Colour the rest of the image in the same manner.

WATERCOLOUR STYLE

This image was actually created in Painter rather than Photoshop, but the results are achievable in both packages. The most obvious difference in this picture is in the delicacy of the palette. Real watercolours are a very transparent medium, so this is reflected in the lightness of the CG. The shading is blended from the midtone to off-white shades, or white – a huge contrast to the bold, strong hues of oil paints. Another difference is the complete lack of black. In a watercolour-style picture it's better to colour in off-black shades, such as dark greys, purples, blues and browns. This helps to keep the image looking soft and light.

Multiplied washes

Just like adding pale washes of colour over a painting, you can add pale washes over your image in CG. This is great for tinting areas. Rather than constantly having to blend colours together, you can just make a new layer and paint straight over them. Setting the layer to Multiply and colouring with light shades will preserve the texture and depth of the shade you've already coloured. The shiny, pink blush on this image was created in this way.

▶ ACRYLIC STYLE

Colouring an image to look like acrylic paint is a mid-point between oil painting and cel-style artwork. Real acrylic paints have the same strong pigments as oils but don't blend, which you can reflect in your colouring. The edges of the colours are much softer than cel-style images, showing the texture of the brush.

▼ PAINTER ADVANTAGES

For creating natural-media-style images, a dedicated natural media simulator like Painter is the easiest way to produce good results. Not only is the brush control more flexible, allowing you to blend and push around colour in a realistic way, but the sheer number of simulated media means it's more akin to having a whole studio full of supplies in your computer. Anything can be reproduced on your computer reasonably faithfully, from traditional materials like oils and watercolour, to less orthodox brushes like the Japanese sumi-e brushes and wax crayons.

Much of the fun from Painter comes from using materials that could never be used together in the same picture. Oil brushes can be used to add a bit of colour to rough sumi-e brush outlines, yet you could never practically mix these techniques on a real canvas. You can paint with the same techniques as a real oil painting (loosely building up colour and tightening the details of the picture as you go), or you can use Layers to keep your painted areas safe from each other.

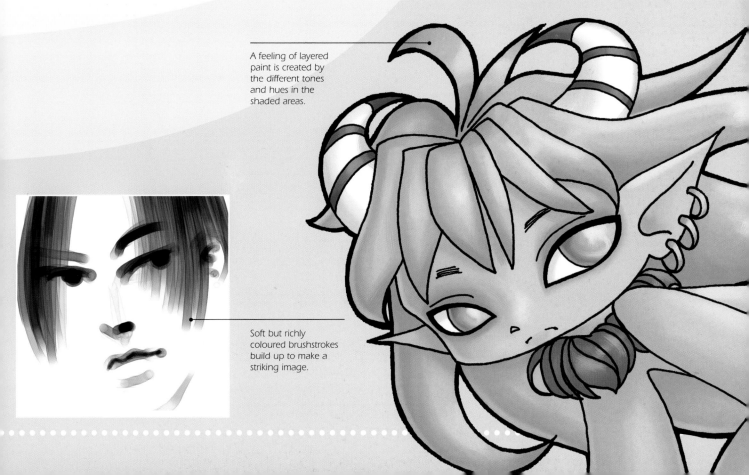

A feeling of layered paint is created by the different tones and hues in the shaded areas.

Soft but richly coloured brushstrokes build up to make a striking image.

Lineless artwork

Images without lines fall into two categories: flat cel style, and a more natural "realism style". Cel style is simple to achieve, and creates an effective look for your images. Natural styles are trickier to pull off, but offer greater versatility in mood.

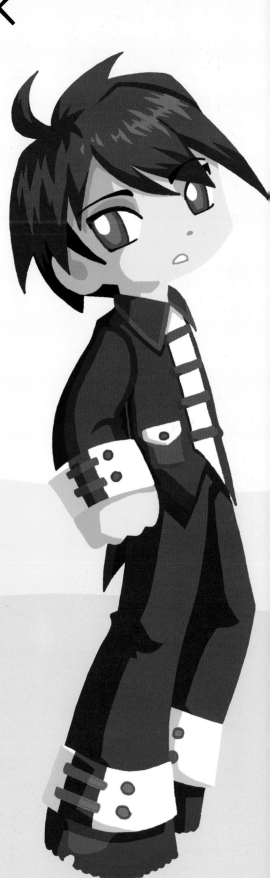

As lineless colouring relies on defining the shape of an object through colour and shade, it's vital to make good colour choices to begin with. Make sure your colours have enough contrast in both hue and shade to keep them clear; muddy, indistinct colouring can confuse a picture, making it difficult for people to understand what you have drawn.

LINELESS CEL STYLE
The lack of a black line gives this style a distinct and bold appearance. Volume is defined entirely through colour and shade.

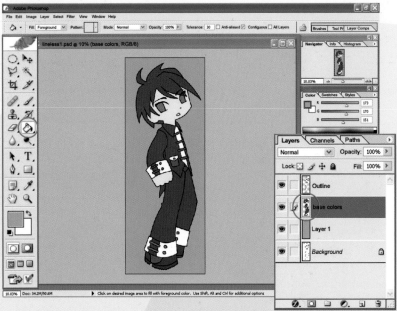

1. Block out base colours Fill in your base colours using one of the methods detailed on pages 66–69. You need to start with pure black and white outlines to be able to colour them easily later. Make sure you turn Anti-aliasing off on both the Fill tool and the Magic Wand.

2. Create a layer for shade Make a new layer between your base colour and outline layers. Lock those two layers for now, to prevent you from accidentally colouring over something important. Select an area you want to colour with the Magic Wand. If the "Contiguous" box is unchecked, you can select all of one particular colour with a single click.

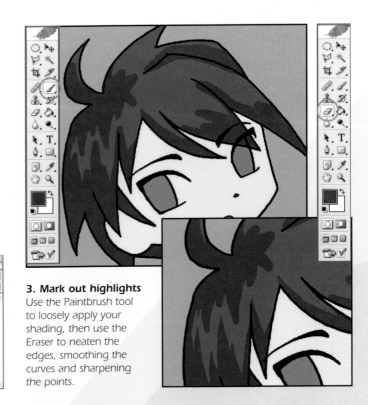

3. Mark out highlights Use the Paintbrush tool to loosely apply your shading, then use the Eraser to neaten the edges, smoothing the curves and sharpening the points.

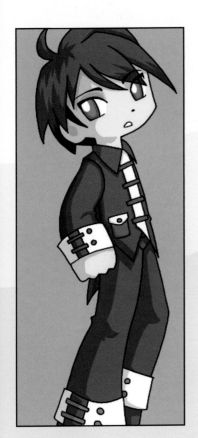

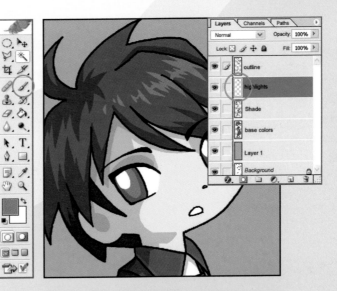

5. Add extra highlights Make a new layer above the shading layer. Use this to add highlights to the image using the same techniques as you used to add shadows. In this picture, highlights are used sparingly to keep the image as clear as possible.

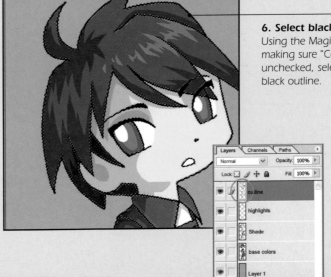

6. Select black outlines Using the Magic Wand, making sure "Contiguous" is unchecked, select your entire black outline.

4. Block out shadows Colour the rest of the shadows. Make sure where areas of the same colour overlap (the legs on this picture, for example) that there's enough shading to make each part distinct from the others. Complex parts of the picture, like the hair, may need more than one step of shading.

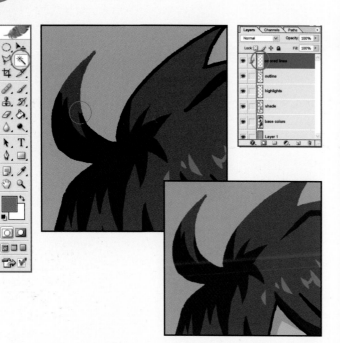

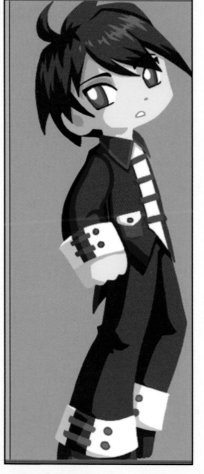

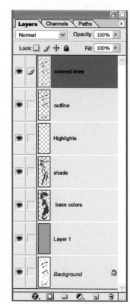

8. The image is complete. (For more on cel–style images, see pages 70–73.)

7. Colour in the lines Make a new layer above your outline layer to recolour the lines. (Working on a new layer will preserve your original lines, just in case anything happens and you need to select them again.) When colouring the lines, remember that lines on top get priority – where two colours overlap, the area that is on top should be used to source the colours for the lines. For example: hair overlaps the face, so the lines between them should be hair-coloured.

See also **Cel-style images, pages 70–73**

TIP Removing Specks of Outline

Black specks appear when the outline is anti-aliased. You can tell if your outline is aliased by zooming into the image. If the line is very black and pixellated, it is aliased; if it's softer and fades from black to grey, it's anti-aliased. This softness makes it more difficult to select the whole outline at once, so you may be left with a fringe of grey.

On the base colour layer, select a colour with the Magic Wand, and expand the selection by 1 or 2 pixels, choosing Select > Modify > Expand from the menu. Quickly colour the offending area with a large brush. If the specks are on the outside of the line, select the area outside of the character, expand it by 1 to 3 pixels and then cut the selection.

LINELESS COLOURING WITHOUT LIGHTING

Lineless images without lighting similar to this one are very popular in Japanese design. The bold shapes make for a striking image, but work best on simple compositions, or illustrations that have a very limited palette.

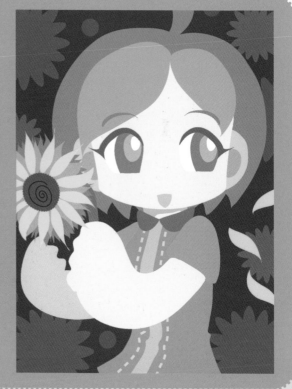

LINELESS REALISM STYLE
Soft brushstrokes and blended colours echo natural media yet retain stylish contrast and definition.

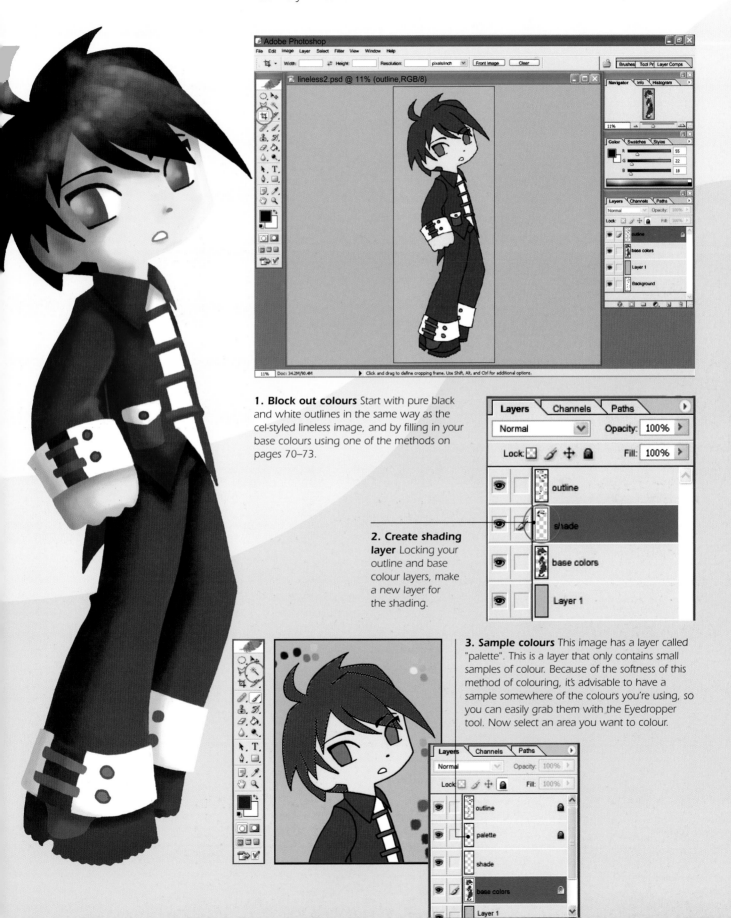

1. Block out colours Start with pure black and white outlines in the same way as the cel-styled lineless image, and by filling in your base colours using one of the methods on pages 70–73.

2. Create shading layer Locking your outline and base colour layers, make a new layer for the shading.

3. Sample colours This image has a layer called "palette". This is a layer that only contains small samples of colour. Because of the softness of this method of colouring, it's advisable to have a sample somewhere of the colours you're using, so you can easily grab them with the Eyedropper tool. Now select an area you want to colour.

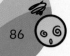

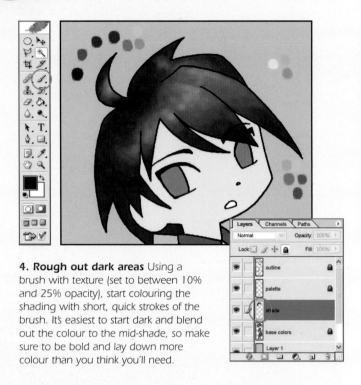

4. Rough out dark areas Using a brush with texture (set to between 10% and 25% opacity), start colouring the shading with short, quick strokes of the brush. It's easiest to start dark and blend out the colour to the mid-shade, so make sure to be bold and lay down more colour than you think you'll need.

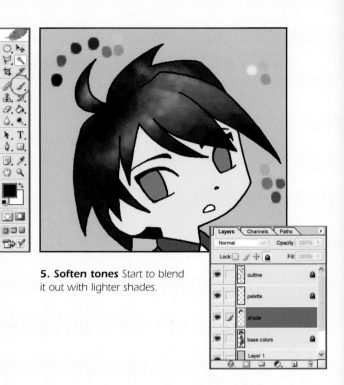

5. Soften tones Start to blend it out with lighter shades.

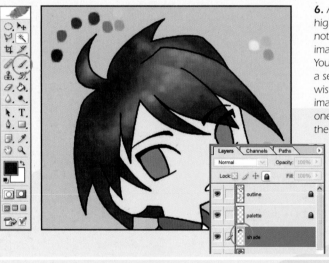

6. Add a few highlights. Be careful not to make the image look too shiny. You can add these on a separate layer if you wish, but in this image we've used one layer for all of the shading.

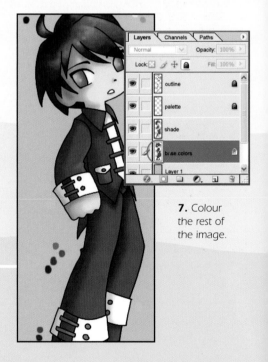

7. Colour the rest of the image.

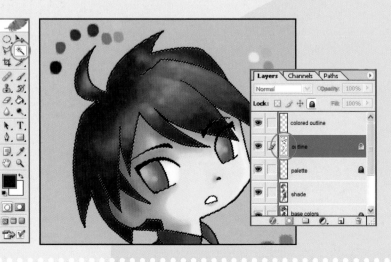

8. Coloured outlines Make a new layer for your coloured lines. Use the Magic Wand to select all the black on your outline layer.

File Edit Image Layer Select Filter View Window Help

Brush: 60 Mode: Normal Opacity: 50% Flow: 100%

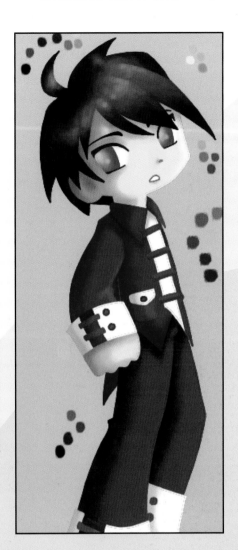

9. Try to match the colour of the lines to the colour of the picture as much as possible. In this case, the same textured brush as earlier is being used, but set to 50% opacity to make it more solid. Holding the Alt key to switch quickly between the Eyedropper and Brush tools makes it easier to pick up and adjust the colour as frequently as you need.

10. The image is complete.

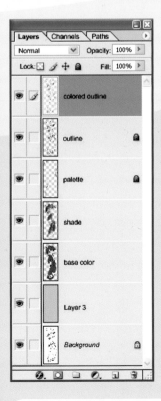

A breakdown of the layers and a reference of the brush sizes used.

Master Diameter 18 px

Use Sample Size

Hardness:

TIP Coloured Lines

If you like the subtlety of an image without lines, but don't want to be so daring as to remove them completely, you can try colouring the lines to match your picture instead. The lines on this image are slightly darker than the coloured area, so it keeps the detail of the original inking, while not overwhelming the colour with black lines.

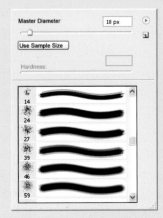

See also **Simulated natural media, pages 78–81**

Digital screentones

Japanese manga is rarely printed in colour, but uses something called "screentone" to introduce shades of grey as well as patterns and texture to its pages.

Screentones traditionally were transparent sheets of adhesive plastic with patterns of black dots printed onto the surface. Illustrators used to use these to create the shading in newspaper cartoons, and in original manga artwork. These dotted sheets, when cut to shape and laid over line work, created the appearance of "grey" shades, and also reproduced easily on conventional printing and copying machines.

The use of dot patterns such as this adds a lot to the readability of a comic, giving you much greater control over the overall style. As a result, using screentone has become synonymous with manga itself, and using it in your work will go some way to creating an authentic style.

The use of screentone relates strongly to the sense of abstraction often present in Japanese artwork. What you're presenting doesn't have to be entirely realistic; it just has to look "right". You can significantly enhance the drama, humour or action of a scene by using patterns and shades effectively.

Thanks to software such as Photoshop and Comicworks, it is possible to emulate old-style screentones accurately on a computer. Careful and restrictive use will help you capture the essence of the technique, while retaining the convenience and flexibility of working digitally.

MOIRÉ

Moiré (or "screen clash") refers to the visual effect caused when two fine patterns are overlaid but misaligned. It is similar to the shimmering effect that net curtains create when they overlap. To prevent this undesirable artefact from occurring, you should avoid rotating and resizing screentone after applying it. It's also worth noting that screentone with a high LPI will be more likely to suffer from moiré because it is more likely to misalign with the arrangement of pixels on a digital image.

HALFTONES

Halftones are the most common type of tone used in manga. These are simple arrangements of dots designed to portray solid shades of grey when used in print. Please note: large dot tones can represent a lack of focus, by using it over a large area.

1. Mark out the areas you wish to be greyscale in simple shades of grey. Choose "Halftone Screen," which will open the dialog box with options.

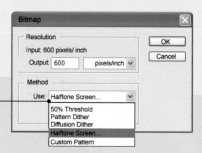

2. Photoshop works best at LPI size of 25, 50 and 100.
3. Be sure to keep line art on a separate layer from the grayscale layer.

Using large halftone dots can indicate a lack of focus, useful for highlighting characters in the background or middle ground.

LPI

LPI stands for "lines per inch", and is a term used almost exclusively for screentone in this context. It refers to how chunky or detailed the pattern is – a low LPI pattern will have very thick lines, whereas a high LPI pattern will have thin and detailed lines.

10 LPI 25 LPI

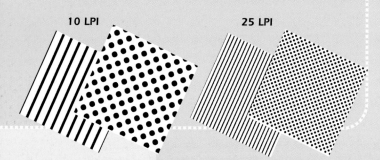

NOISE OR SAND TONE

Noise tones are useful for introducing texture, as well as serving a dramatic purpose.

GRADIENT TONE

Gradients can add depth and definition to manga images, as well as helping to define shiny materials.

GEOMETRICAL TONE

Simple vertical lines serve many purposes in drawing manga.

1. Create a new layer, and fill out an area of the image you wish to be noise with a 50% grey shade. This effect can also be applied to a gradient.
2. From the Filter menu, choose "Pixellate," then "Pointillize".
3. Set the size of the filter. The larger the number, the coarser the noise tone will be. A value between 5 and 10 should be fine for most purposes. On a high-DPI image you will need a coarser tone to achieve the same effect than on a lower-DPI image.
4. Adjust Brightness and Contrast in the image so that Contrast is 100%, and Brightness is as high as you wish. This will also change the overall tone of the image.

1. Selecting black and white as your foreground and background colours, create a gradient using the gradient tone.
2. Convert to Halftone or Noise using the same procedure as before.
3. When using noise gradients, consider layering the tone and moving around to achieve greater definition.

Follow the same procedure for regular halftone artwork, but choose "Lines" or "Checks" for the pattern.

TONE FEATHERING

Using a layer set to "Dissolve", the greys of the image will be interpreted as fine patterns of dots. This can be achieved to "feather" the edge of screentone, as though a sheet of screentone had been rubbed away. You can use a large, white Airbrush for a soft edge, or a small, hard brush moved in patterns to create an interesting transition.

TIP Making Coarse Tone

Often using digital screentones can create a pattern that is too fine, making it less than ideal for print and giving you textureless results.
1. Go to: Filter > Blur > Gaussian Blur. The higher the value chosen for Blur, the coarser the image will be. A value of 1.0 and 2.0 should be okay.
2. Convert the image to Halftone, using the Mode option in the Image menu. Choose an LPI of 50.
3. The gradient will now be much coarser, and have a more distinctive texture when printed.

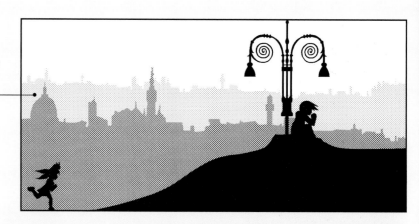

Backgrounds can be simply and effectively represented by layers of screentone.

USING YOUR OWN PATTERNS

There are books available containing copyright-free tone patterns, which you can scan into your computer and use freely in your manga work. You can also still buy sheets of original adhesive screentone and scan them for your own personal use.

SPECIALIST SCREENTONING SOFTWARE
Comicworks

Comicworks is produced by Deleter, a company whose business revolves entirely around supplying traditional printed screentones to the Japanese comic industry. As a result, Comicworks is designed from the ground up for the production of manga, and has great screentone facilities.

More than 140 different tones and patterns come provided with the software, stored in the software at high clarity and 1200 dpi, 600 dpi and 300 dpi sizes, meaning they are always perfect for print work. If you're keen on the process of applying screentone in manga, then Comicworks will be ideal.

APPLYING SCREENTONE

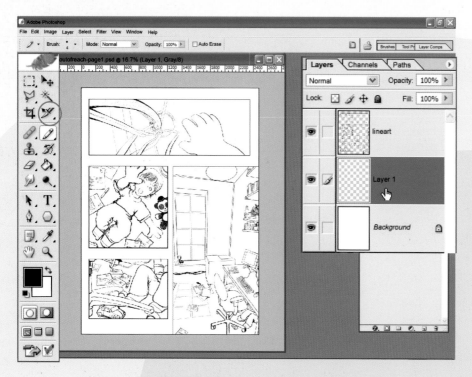

1. Set up a line art layer Start with a new Photoshop document, and set up your line art on the topmost layer, as you would with a coloured piece. It is especially helpful to lock this layer, as you can ruin your page by applying screentone to the line art layer.

TIP Keeping Grey Layers Hidden

Be sure to keep your original grey layers intact (set as "Hidden") even after you have made a halftone equivalent. This allows you to come back to the image at a later stage and alter the toning or reapply the screentone with a different LPI. This can be useful if you have to print the image at a different size, or decide to change the image after doing test prints.

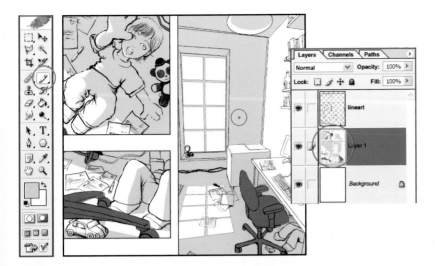

2. Block out basic shading
Create a new layer, set to "Multiply". Choose a grey brush and begin to mark out the areas of the page you want to shade, paying attention to the light source. In this case, the artist has also marked some objects with a darker tone.

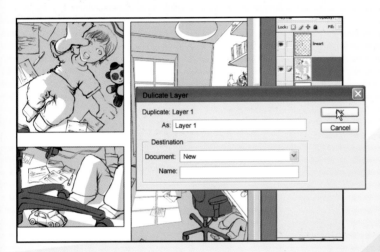

4. Convert grey to black and white
From the Image menu, choose Mode, and then Bitmap. If your image isn't greyscale already, you will need to convert to greyscale in the Mode menu before doing this.

3. Right-click on the layer, and choose "Duplicate". Select "New" from the Destination dropdown list to create a new document.

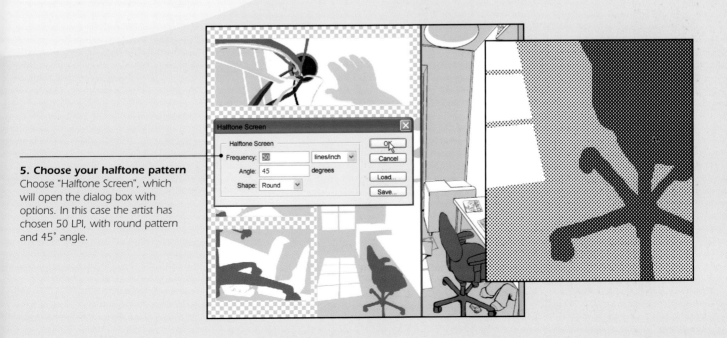

5. Choose your halftone pattern
Choose "Halftone Screen", which will open the dialog box with options. In this case the artist has chosen 50 LPI, with round pattern and 45° angle.

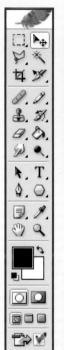

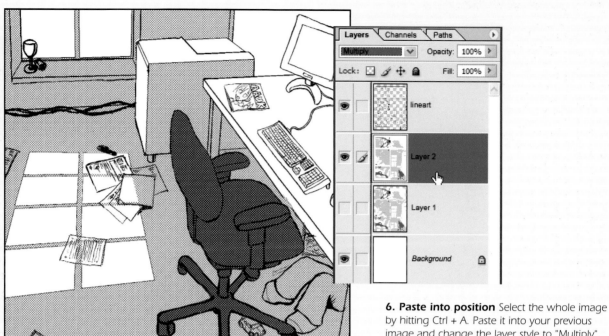

6. Paste into position Select the whole image by hitting Ctrl + A. Paste it into your previous image and change the layer style to "Multiply". Hide your previous greyscale layer.

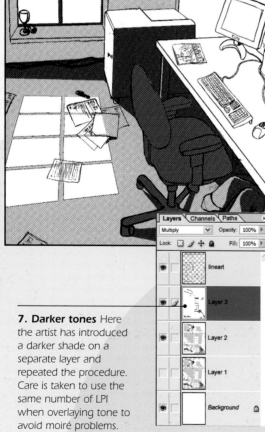

7. Darker tones Here the artist has introduced a darker shade on a separate layer and repeated the procedure. Care is taken to use the same number of LPI when overlaying tone to avoid moiré problems.

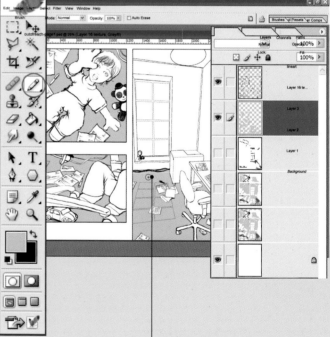

8. Introducing fabric textures In order to apply texture to the image, the artist has hidden all tone layers and marked out the carpeted area of the image with a grey brush.

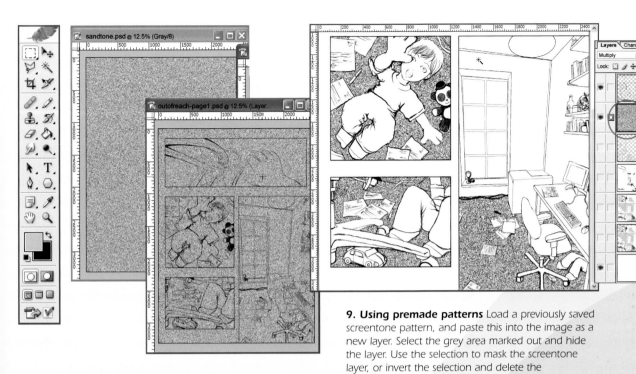

9. Using premade patterns Load a previously saved screentone pattern, and paste this into the image as a new layer. Select the grey area marked out and hide the layer. Use the selection to mask the screentone layer, or invert the selection and delete the excess screentone.

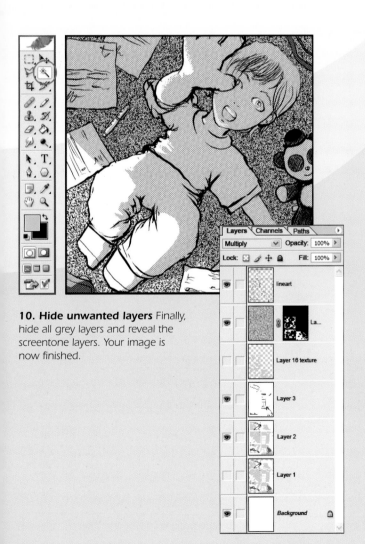

10. Hide unwanted layers Finally, hide all grey layers and reveal the screentone layers. Your image is now finished.

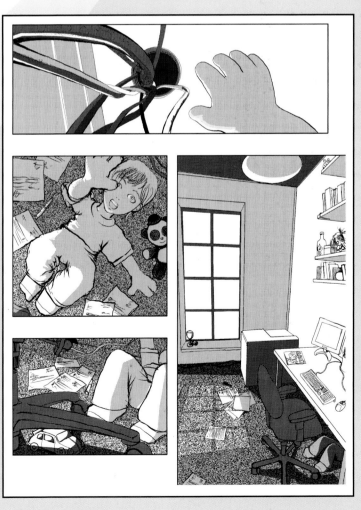

Special effects

One of the characteristic aspects of manga is its use of abstract patterns in the background of scenes to help capture the emotion or action of the current event. This technique has been developed over many decades and is now closely identified with the style.

Using Photoshop, you can emulate many of these types of effects very simply on your home computer. Just a few steps can produce professional effects that would look at home in a professionally printed Japanese manga.

PATTERN FOUNDATIONS

1. Create a new, large greyscale image, and choose black and white as the foreground and background colours.

2. From the Filter menu, choose "Clouds" from the Render submenu.

3. Alternatively, choose "Difference Clouds" from the Render submenu, and then repeat this. If you repeated, apply this filter (use Ctrl + F as a shortcut); the pattern will become more erratic and fiery, which will introduce more varied and interesting results.

4. Now you're ready to apply filters and produce action lines. You may wish to save this "Clouds" image to disk if you find the filters are slow.

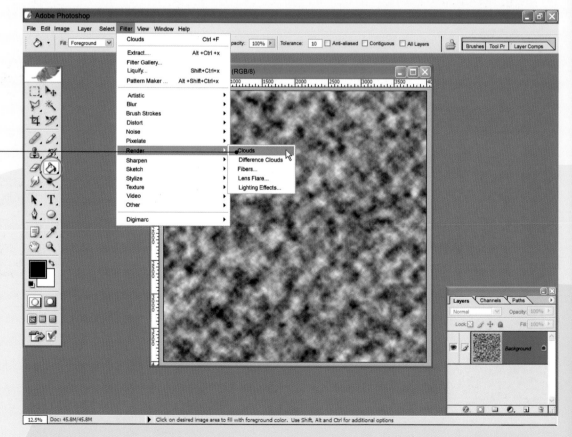

IMPACT ZOOM
Lines of irregular width but with the same emanating point accentuate action and impact.

1. Starting with the Cloud filter apply the Pinch filter from the Distort submenu, with a setting of 100%.

2. Repeat this filter ten times. You may wish to use more or fewer times depending upon the results you wish to achieve.

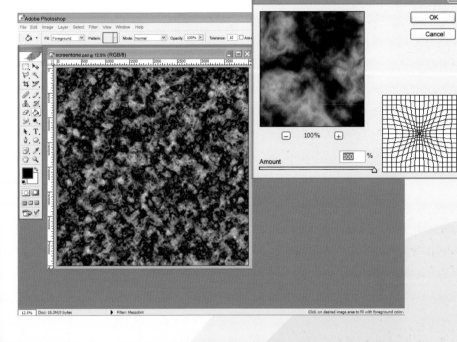

3. Using the Brightness and Contrast tool, raise the Contrast to full, and Brightness to whatever level you desire.

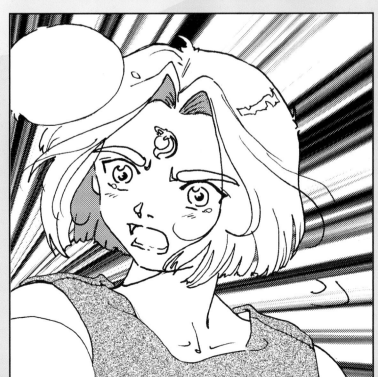

4. Convert the final image to halftone using the Bitmap option.

IMPACT SWIRL
Lines spinning around a
centrepoint suggest an arc
of movement.

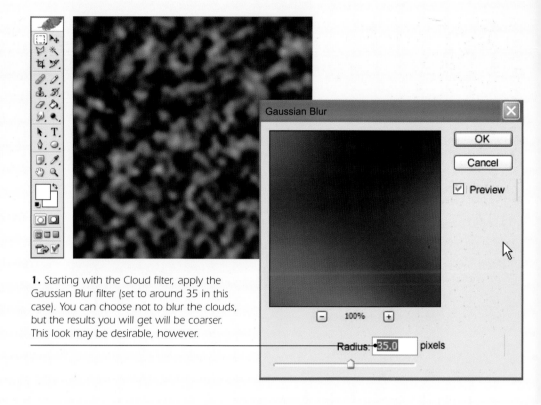

1. Starting with the Cloud filter, apply the
Gaussian Blur filter (set to around 35 in this
case). You can choose not to blur the clouds,
but the results you will get will be coarser.
This look may be desirable, however.

IMPACT ZOOM AND SWIRL
By twisting the impact lines, the effect
suggests something uncontrollable.

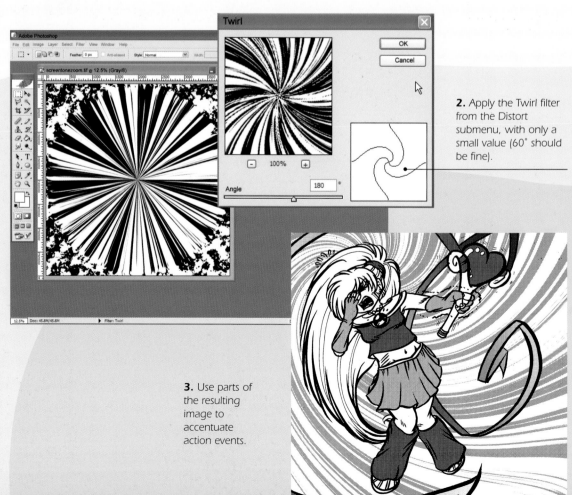

1. Create the
Impact Zoom effect,
ending up with a
dense black
implosion image.

2. Apply the Twirl filter
from the Distort
submenu, with only a
small value (60˚ should
be fine).

3. Use parts of
the resulting
image to
accentuate
action events.

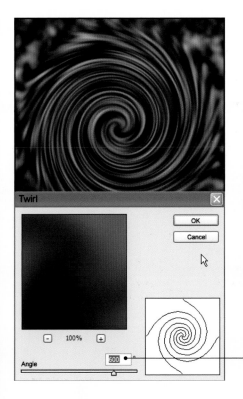

2. Choose the Twirl filter from the Distort submenu.

3. Choose 600° for the angle. You can raise and lower this to vary the results.

4. Increase the brightness and contrast.

5. Convert the final image to halftone if intended for use in print.

SHOUJO SPARKLES

Characters' emotions are represented by mysterious sparkles of light.

1. Create a new layer, set to "Multiply".

2. Fill in some opaque circles, ovals or hexagons in white.

3. Right-click on the layer, and choose "Layer styles".

4. Disable "Stroke", and check the box next to "Outer Glow."

5. Set Colour to black, Opacity to 30% and Style to "Dissolve."

6. Change the distance under the dots spread out from the circle.

7. Create a new layer with the same layer style (copy and paste the layer style by right-clicking on the layer). Alternatively, right-click on the layer and select "Duplicate Layer".

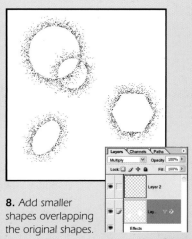

8. Add smaller shapes overlapping the original shapes.

9. Flatten the image (see page 52), apply Gaussian Blur and convert to halftone. This will make the tone coarser, as described in Digital Screentones (see page 89).

GRITTY ANGST

Personal torment can be conveyed by the use of gritty, dark patterns.

3. Choose the Long Strokes filter to create the desired effect.

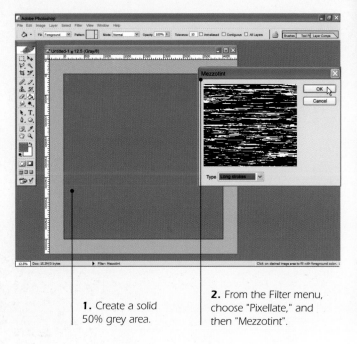

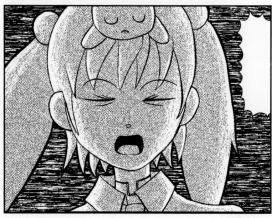

1. Create a solid 50% grey area.

2. From the Filter menu, choose "Pixellate," and then "Mezzotint".

EMOTIONAL WISPS

Trails of dust and energy help to exaggerate a sense of melancholia.

1. With a regular white image, create a new layer set to "Dissolve".

2. Using a medium-sized black Airbrush with Flow set to 10%, create curved strokes across the page. Varying the pressure with the graphics tablet will help to create varied width.

3. Repeat the effect over the page many times, and then Flatten the image.

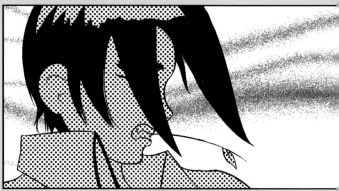

SENTIMENTAL PATTERN

Heavenly sparkles of white help to portray hopeful or whimsical feelings.

1. Create a solid 75% grey image, making sure it is 300 or 600 dpi.

2. Convert the image to Bitmap, and choose the Halftone option.

3. Choose "20 LPI", and the "Cross" pattern option. This will create a mesh effect.

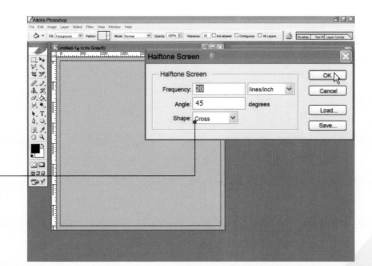

4. Create a new layer, set to the "Dissolve" layer style.

MAKING YOUR OWN PATTERNS

Although most screentones in manga use simple patterns, shapes and lines to express the tone or atmosphere of the image, there are also a lot of other available styles created from patterns of small images. These are great if you're trying to express a funny emotion or scene.

You can easily make a pattern by drawing something and defining it as a Pattern in Photoshop. Select the area you wish to define as a pattern, and then choose "Define Pattern" from the Edit menu. You can then fill areas with this pattern by choosing "Pattern" from the Fill tool options.

There are even some typefaces available on the Internet that feature images instead of standard letterforms. These are sometimes known as "Dingbats". These can be used as a basis for patterns, by selecting a few images and arranging them appropriately. As always, the secret is to experiment and have fun!

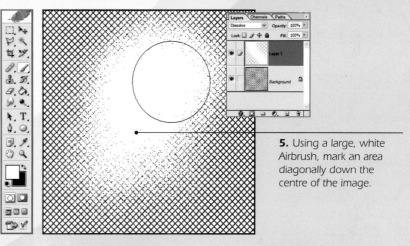

5. Using a large, white Airbrush, mark an area diagonally down the centre of the image.

6. Add a few smaller white dots, and Flatten the image layers. Your tone is now ready.

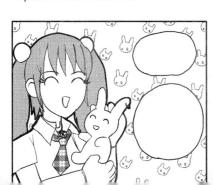

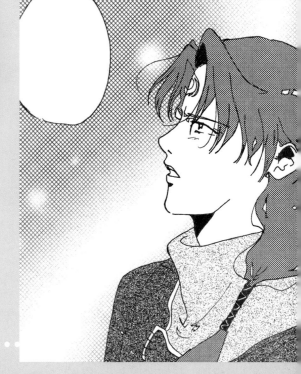

CHAPTER SIX
Creating pages

A completed manga can be hard work, but with a little planning you can avoid problems and ensure that your finished piece looks as good in print as you always dreamt it would.

Planning your pages 102

Inking pages 104

Using effects 106

Adding tone and colour 108

Adding speech and sounds 110

Concept to completion 112

Web comics 114

Printing and publishing 118

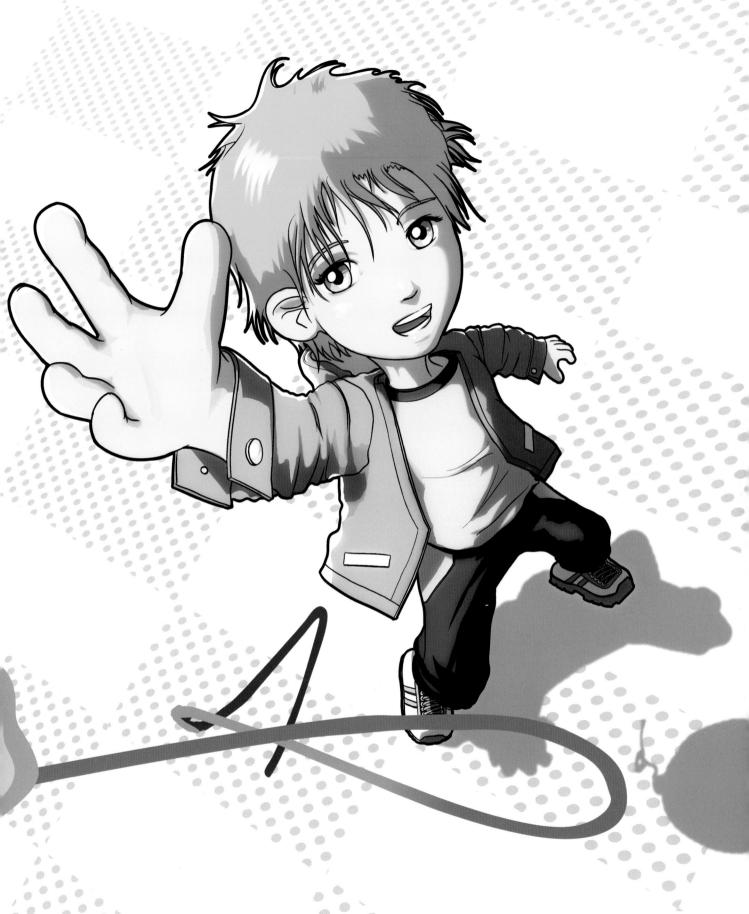

Planning your pages

Once you've come up with your character concepts, the real work begins. Here are some top tips and techniques for making the most of your inspiration.

PLANNING YOUR MANGA

You've conceived your characters and they've taken on lives of their own – at least in your imagination. So how do you get them from the world inside your head into the real world for other people to appreciate? Draw a manga, of course! However, all manga have to start somewhere, whether they're ten-page vignettes, or one-thousand-page epics. Planning is key, and scripts and thumbnails are two techniques whereby you can begin to design how your pages will look.

WHAT ARE THUMBNAILS?

Thumbnails are small, rough sketches that artists use to plan the layouts and/or story of their comics. Whether you're an artist working with a writer or working alone, thumbnails are an ideal way of making sense of the script and organizing your ideas before you commit yourself to the full-size pencilled pages of the comic itself.

TIPS for Better Thumbnails

If you are going for large thumbnails, make them roughly the size that the printed comic will be. A good size is 148 mm x 210 mm (5.83 in. x 8.27 in.) since these dimensions are similar to those of a graphic novel or a self-published comic. This way you won't be tempted to overfill the panels with too many details.

Know what the last page will be. If you have a precise ending in mind, it makes getting there a lot easier.

Finish all the thumbnails before you start drawing the pages. You might find you need to change your layouts once you've started work on the real thing. Make sure you've finalized everything before the next step.

Reading direction

The pages of Japanese printed comics are read in the opposite direction to Western comics, as are the panels on each page. As Japanese text is read from right to left when written in columns, it also means that it is more familiar for Japanese readers to read pages from right to left. Western manga artists, however, tend to produce their work reading from left to right, as Western readers are familiar with this format. All the pages and examples in this book are from Western artists working from left to right.

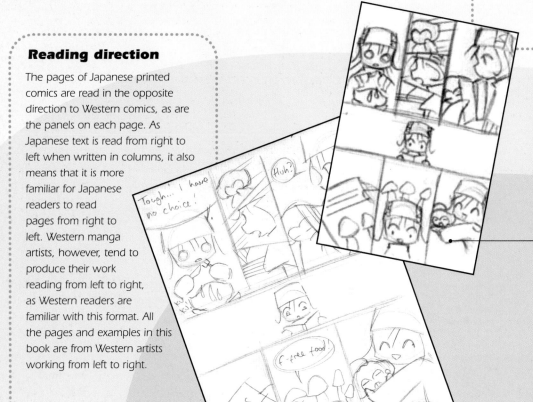

Small thumbnails

Small thumbnails are only about 5 cm x 7.5 cm (2 in. x 3 in.) in size. Because they are so tiny, you can fit the proposed layouts for several pages onto a single sheet of A4. But their size means you will have no space for speech bubbles or dialogue, so this method is only recommended if you are working from a written script.

Large thumbnails

Larger thumbnails give you much more space for dialogue and notes, so you can skip the written script entirely and go straight to planning the layouts. This is more practical for artists working alone.

DRAWING THUMBNAILS

So you're all ready to draw your layouts, but where do you start? Even with a clear image of the story in your head, you need to learn a few basic rules about panels before you can piece everything together.

Pacing

On a basic level, the size of your panels affects the pace of your comic. Large, wide panels slow the story down by lingering on details in the background, or by drawing attention to an intense, dramatic moment in the story. These types of panels are also best for setting the scene of your comic, as they have the most space for creating or introducing environments. Conversely, smaller panels speed up the pace. With little detail or room for dialogue, they are quick to read and can create a more urgent pace. Small panels are particularly useful for drawing action and battle sequences, where you can use a lot of small details to illustrate a much bigger event. Details like these help keep the action exciting, and more important, make the comic more coherent for the reader.

Flow

When drawing a comic, you must make sure your panels read in the correct order. This might sound obvious, but even some experienced artists make mistakes in their panel flow. If you find yourself putting arrows on the pages to direct your readers, your panels are in the wrong order!

What to draw (or what not to draw!)

Although thumbnails are very important in planning your comic, that doesn't mean each one has to be a masterpiece. Putting in too much detail at this stage will only exhaust your enthusiasm for drawing the final pages. The most important things to focus on when drawing thumbnails are expressions, gestures and perspectives.

Advantages of adding dialogue

Adding dialogue to thumbnails is by no means essential; however, it is an easy way to shorten the planning process. Rather than basing your thumbnails on a written script, you can instead start drawing from your imagination, adding dialogue as you go. Doing it all at once gives you more freedom to adjust the pacing to suit the dialogue. It's also easier to picture your characters moving and interacting with their surroundings as they talk. Adding dialogue to thumbnails gives you an estimate of the size of the speech bubbles on the finished page too, so you can avoid cluttering tiny panels with too much text, or leaving yourself too small a bubble for key sections of dialogue.

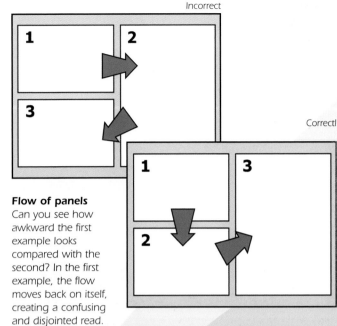

Incorrect

Correct!

Flow of panels
Can you see how awkward the first example looks compared with the second? In the first example, the flow moves back on itself, creating a confusing and disjointed read. But why does the second example look more natural than the first? Your eye always looks for the longest panel gutter, and divides the page accordingly. Then each section is read in order before going to the next. In this case, there is a long gutter running down the centre of the page, grouping panels 1 and 2 together, while also separating them from panel 3. All comic pages section off and group together panels like this.

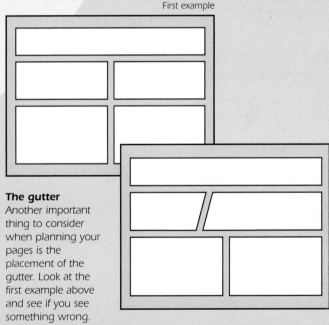

First example

The gutter
Another important thing to consider when planning your pages is the placement of the gutter. Look at the first example above and see if you see something wrong. Confused? Even though the panels are not necessarily in the wrong order, it's impossible to know which way to read them. This is because the gutter meets like a crossroad in the middle of four of the panels. But if you take the vertical gutter and break it up like the second example, the page suddenly becomes readable. Now it's obvious which order the panels are in. Just keep these examples in mind, and you should have no problems ensuring your panels flow in the right direction.

Inking pages

Inking your pages will be the most important step in making your artwork look slick and professional. Even flawed artwork will appear much stronger if you take care and pay attention when inking the lines. Here are some of the techniques to master.

Blocking in blacks
Using solid black for certain parts of clothing or costumes can be especially good for creating definition and contrast within the page. Take this into consideration when designing your characters.

Line width for depth
Consider the thickness of lines when producing your line art. Pay attention to the location of the characters, and to the focal point of the scene. Using thinner lines in the background will help to emphasize perspective and the relative distance of objects to foreground characters.

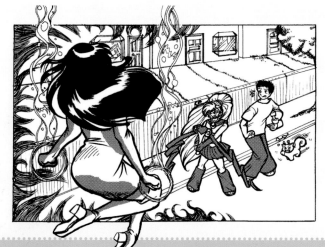

See also **Using effects, pages 106–107**

HOW TO CREATE COMIC PANELS EASILY AND FLEXIBLY

This technique will allow you to adjust and alter the shape of your panels quickly, as well as adjust the thickness of the panels at a later stage.

Layer Properties...
Blending Options...

Duplicate Layer...
Delete Layer

Enable Layer Mask

Rasterize Layer

Copy Layer Style
Paste Layer Style
Paste Layer Style to Linked
Clear Layer Style

Right-click on the layer and choose Blending Options.

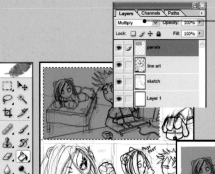

After creating a new layer in Photoshop (set to Multiply), use the rectangular selection tool to define the outline of your panel. Fill this with a bright colour, such as red (you can use a medium grey if your file is greyscale).

Repeat this to define all your comic panels.

Now activate the Stroke option. Choose "Inside" for the Position option and raise the thickness to a value of 10 to 16 pixels for a 600 dpi page (halve this for 300 dpi). Change the stroke colour to black, and you now have your panel outlines.

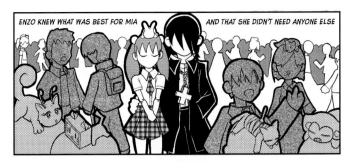

Defining your character with a thicker outline

This is a stylized and abstract technique that won't suit every style, or indeed every panel, but sometimes it can help greatly when distinguishing one specific character from others. It is especially useful in crowd scenes, where you may need to focus greater attention on your protagonist, or on a significant character in the scene.

Drawing panels

It is often better to draw your panel outlines straight onto the computer than to draw them directly on the page. It ensures the lines are perfectly straight and properly aligned.

Quick line strokes
These lines are drawn straight to the page, so they will be more permanent.

TIP: Shift Key

Holding down the Shift key will help greatly when drawing straight lines, such as panel outlines, onto the page, as it ensures that your cursor only moves horizontally or vertically, depending on the direction of the stroke.

Without the Shift key held down

With the Shift key held down

If you hit Shift before starting a new line, it will join a line between the end of the previous line and the beginning of the new one.

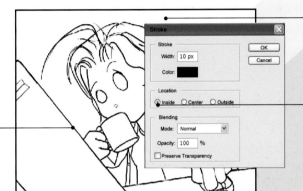

Create a selection. Right-click on the page and choose Stroke.

Choose Inside for your Location option, and raise the thickness to a value of 10 to 16 pixels for a 600 dpi page (halve this for 300 dpi). Change the colour to black. Click "OK".

You can change and edit your panels as much as you like at this stage. The outline will adjust itself to the new panel sizes or changes.

If you wish to make this layer permanent, you must merge it with a blank layer. Choose "Layer > Merge Down" from the menu, or press Ctrl + E.

Once you are done, fill in your panels with white, or use the Colour Overlay style. You will also want to trim the excess lines from your line-art layer, or block them out on a new layer with white.

Alternatively, you can draw the borders instead of the panels themselves (as shown in green in the diagram). Be sure to change the stroke outline position to "Outside".

Using effects

Adding special effects with screentone or colour will make your comic appear more dynamic and visually appealing – as well as help communicate your story and the characters' emotions better to the reader. Just like in a film, special effects grab our attention and entertain us – as long as the story is strong too!

SPECIAL INKING EFFECTS

Here are some simple inking techniques to really get your artwork noticed.

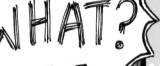

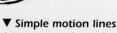

◀ Blurring motion lines
To represent movement within your image, break up the lines and make them less distinct, as though the object is moving too quickly to be seen clearly – like a stylized form of motion blur in a photograph.

▲ Broken lines
Sometimes it is effective to leave gaps in your line art, when it is obvious how the shape is defined. This gives the impression of sunlight shining and obscuring the outline of the character, but can be used in other instances too. The technique is most commonly used in shoujo comics (see Shoujo, pages 12–13).

▼ Simple motion lines
A less extreme form of speed line, drawing short lines parallel to existing lines helps to imply small amounts of motion. This can also help to define turning or even shaking motions.

◀ Multiple outlines
Extra outlines give the image an extreme or startled look, helping to exaggerate comical expressions or moments of fear. The effect is like a scribble, but controlled so that it looks consistent and follows the shape of the original image.

See also **Special effects**, pages 94–99

SCREENTONE EFFECTS

▶ Associating emotions with screentone

If you consistently use a particular screentone when a specific emotion or conflict is occurring, the presence of the screentone itself can begin to represent the emotion. Although this is a subtle effect, and shouldn't be relied upon to gain the reader's understanding, it can be an effective representation if used well.

▼ Using appropriate screentone

Make sure you use the appropriate screentone for the situation. Applying the wrong screentone will change the mood of the panel, and communicate the wrong idea to the reader. Remember: in manga, everything on the page is significant – it's a graphical language – so use screentone to complement the action represented by the image, rather than conflict with it.

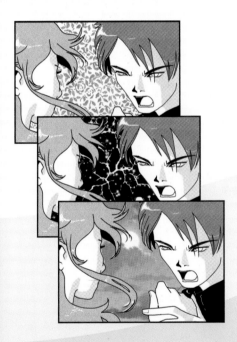

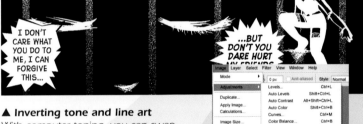

▲ Inverting tone and line art

With computer toning, you can swap the black and white elements of any screentone to create an eye-catching effect. You can use the technique for dramatic purposes, or just to effect a change in mood. Sometimes inverting the whole panel, including the line art, can be especially impressive. Like most dramatic techniques, use it only in moderation.

Choosing the Invert function will swap the black and white in your artwork.

Using parts of tone

Pattern tones, which have white areas between design elements, are often more effective if the whole tone isn't used. Just grabbing one or two bubbles or deleting some of the flowers can help complement the artwork in the panel much better.

Using small areas of this tone will enhance the artwork more subtly.

◀ Use your imagination!

By using small sections of very large tones, you can change their appearance to make the patterns seem interesting and original in certain instances. For this girl's bikini top, for example, a pattern was needed to imply a design on the garment. Using a sheet of large "vortex" design tone, and inverting the colours, some very small areas of it could be used, and the effect was very different from the original tone (so the reader did not see it as screentone). The final result was this stylish bikini design.

This large print looks different when small parts are used.

Adding tone and colour

Tone and colour are as vital to the success of your artwork as being a master of line and form. So what are the essential considerations for adding these elements to your manga?

When adding colour or tone to a page, you need to consider both the impact of the whole page and its composition. Your colour usage on each panel affects the overall appearance of both the page and the comic as a whole, and you can control balance and emotion with your use of black and white and different tones.

Working with contrast
When producing manga it is helpful to make creative use of mid-tones in the form of screentone. However, it is also important to maintain a high level of contrast between your selections to accentuate composition, and the flow of the page. This will also ensure that the essential details and focal points of your artwork are vivid, and leave the reader in no doubt as to what is happening on the page.

Dramatic lighting
Lighting within the panels need not be entirely realistic in every scenario. Abstract, expressive or emotive use of light can help communicate the mood and atmosphere of each scene very effectively.

Not every panel needs heavy shading
The use of detailed shading in a panel or short sequence of panels is as much of a storytelling device as your line art or dialogue – it is one of the best ways of drawing attention to some aspect of a character's personality, or a pivotal event in the story.

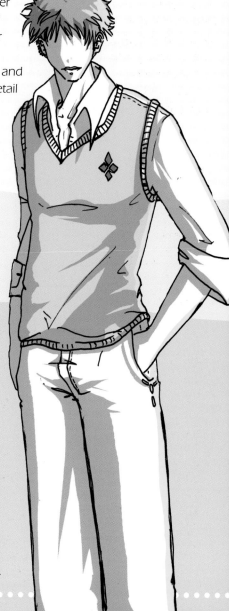

However, it is a bad idea to pay every character the same amount of attention: allow your reader to focus on particular characters and events. Too much detail means that no character gets the focus he or she needs, as well as making the panels themselves more difficult to follow.

▼ **Shading out the eyes**
This is a bold statement, implying sadness or seclusion in the character, or perhaps an evasive nature. Use these techniques no more than once or twice in your comic to maintain their potency.

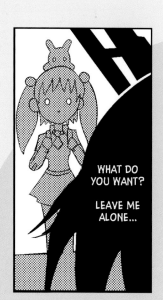

WHAT DO YOU WANT?

LEAVE ME ALONE...

▶ **Expressive lighting**
Tone and colour can be used in an expressive way to convey the atmosphere of a scene.

◀ **Bright eyes**
One useful artistic device is showing a character's eyes lit when the rest of the panel is unlit or dark. Although this is obviously not naturalistic, it can be highly expressive and help readers identify with a particular moment in the story.

TIP: Blacking Out

Black out a character that is standing against a tone background. This creates a striking presence without focusing on details.

▲ Abstraction

If you treat your colours like a special effect, you can achieve some impressive results with block tones. Using these to represent emotional presence or abstract moods can help to underline the themes of your story.

WORKING WITH COLOUR

Producing comics in colour is in many ways much more difficult than producing them in black and white, especially when working with the many abstract methods that are typical of manga style. Most artists don't use colour at all, but many of the same principles of black and white manga can be applied to colour works.

▶ Maintaining a palette

Try to keep your tonal ranges and colour choices consistent throughout the scene, giving the reader a strong sensation of familiarity of the location. A limited palette will make the comic much easier to read and help express the mood of your story.

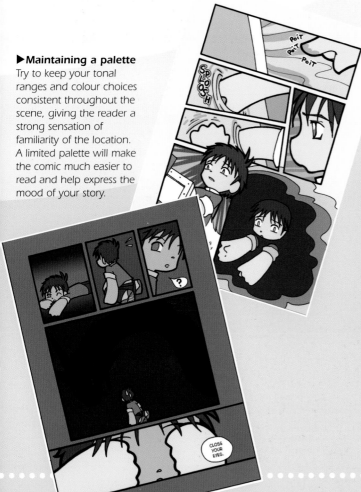

Colour considerations

Bear in mind that working in colour will make it difficult for you to print your comic cheaply, and the cost per comic will often be too high to sell. However, colour comics work great on the Internet, and there are no production cost differences between them and greyscale comics. If you keep your original artwork layered (in Photoshop), it will allow you to adjust your toning at a later stage, should you wish to produce a black-and-white version for print, or, conversely, to remove the screentone and redo the pages in colour. You can also colour your screentone layer – with the Colourize option from Photoshop's Hue/Saturation toolset, for example.

See also **Printing and publishing, pages 118–123**

Adding speech and sounds

Speech bubbles and graphical representations of sounds are vital elements to get right. They add to the visual appeal of your work, and aid its comprehension.

THINGS TO AVOID

Because introducing dialogue and sound effects into your comic is an important part of designing each page, it is worth giving them plenty of time and attention. They have a huge effect on how the reader will enjoy your work, and every speech bubble is as much a focal point as your painstakingly drawn artwork. Here are some important things to look out for.

BUBBLE BASICS

Outlines for bubbles
The outline for the bubbles shouldn't overpower the artwork, but merely help maintain the clarity and location of text.

The shape of bubbles
Rounded bubbles represent ordinary dialogue, or even heated conversation. Spiky and angular bubbles have impact and are perfect for words that are shouted or spoken sternly.

▶ **Crossed bubbles**
Avoid crossing over the bubbles, as the flow will be unnatural and difficult to follow. Ideally, the panel should be designed with the panel flow (including the dialogue flow) in mind before going ahead and drawing the bubbles.

▼ ▶ **Interjections**
Avoid interjections within a solitary panel. It shouldn't be necessary for a character to speak twice within the same panel, other than during a natural break within the dialogue, perhaps. To have a character speak, another character respond, and then the first character reply again negates much of the emotional impact of the conversation. Creating another panel to contain the reaction works much more effectively.

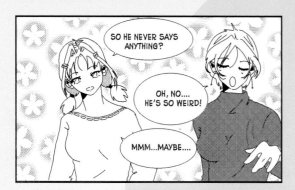

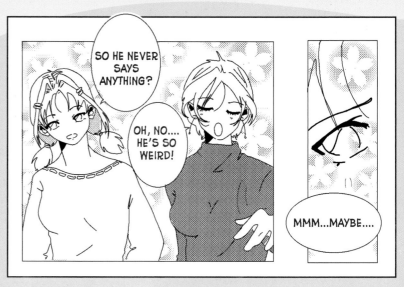

Font issues

Because of the informal nature of text placement within comics, most writers prefer to capitalize their text. This helps the individual letters fit the shape of a speech bubble without looking weak. However, some artists do prefer not to capitalize their text. Experiment and decide which is the most appropriate approach for your title.

Try to stick to a regular font size for your comic's main text. This makes it easier to read, and goes some way towards making your work look more professional. It also allows you to create more impact when you do decide to use large or small text.

Background text

Using small text in the background of a panel is a common device in manga. Almost always used for comedy, it suggests the idea of a character muttering something under his or her breath, or someone saying something in the background. The comic will read fine without it, but these extra elements provide a light-hearted edge, or help to express the behaviour of characters in the background.

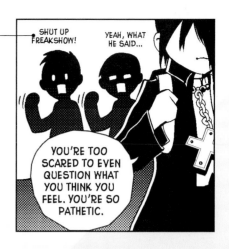

BLOCKING OUT BUBBLES

You can block out speech bubbles in Photoshop with the same technique you use for panels, but using the Elliptical selection instead. (See Inking Pages, page 104.) However, these can look too synthetic and clash with your artwork. Experiment and see which technique suits your style.

HOW TO PLACE TEXT IN PHOTOSHOP

Choose the Text tool from the Photoshop toolbar.

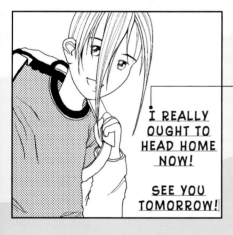

Method 1: basic text
Click on the image where you want to place the text. If you want to start a new line of text, hit the Enter key.

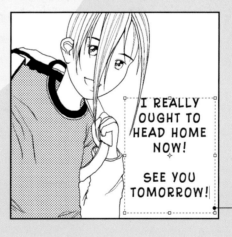

Method 2: text area
Click on the spot where you want the text box to begin and hold down the mouse button to drag out a box. This is a text area, which will define the area within which the text will fall.

OTHER FORMS OF TEXT IN BUBBLES

Symbols or punctuation marks can be used in speech bubbles, as a simple and effective way to communicate what is happening to the characters.

The skull and crossbones implies that the character has been poisoned.

One common technique in manga is to use three dots to represent a character's silence. This can be useful to demonstrate when a character is expected to talk, but says nothing at all.

See also **Special effects**, pages 94–99

Concept to completion

Here are all the main stages in taking the world of the artist's imagination to the realm of the printed page or Web page. Enjoy the journey!

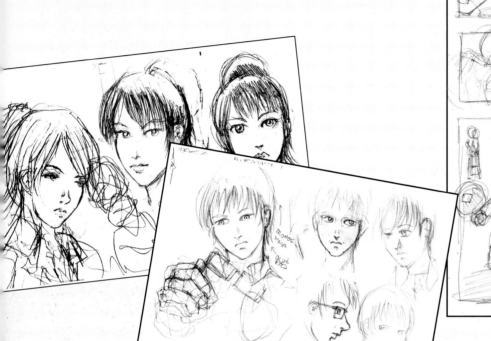

▲ Step one
When you've conceived your story, sketch out character designs (above) so that there is a feel for what they will look like. With short stories, it is less important to develop these designs, as the characters will only make a brief appearance, but with larger stories more detailed designs are necessary.

▲ Step two
Sketch out the pages as "thumbnails" with very rough artwork. These can be changed and adjusted easily until the story flows nicely, before you produce final ink versions.

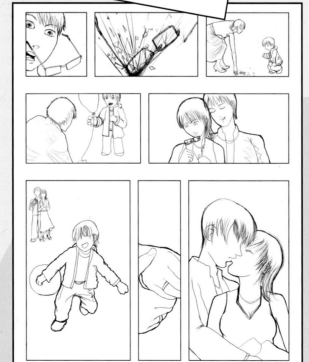

◄ Step three
After drawing out neat line art in pencils, apply your inks. In this example, the speech bubbles are going to be added by computer, so the artist has left them off the original lines.

▼ Step four

A combination of flat, grey tones and pattern tones have been used here to add shade and definition to the artwork. Speech bubbles have also been added to the image, paying attention to the original sketches for their placement in relation to the artwork. The page is now finished, and ready to go to print. Try this approach and see if it works for you.

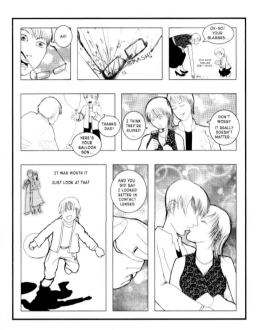

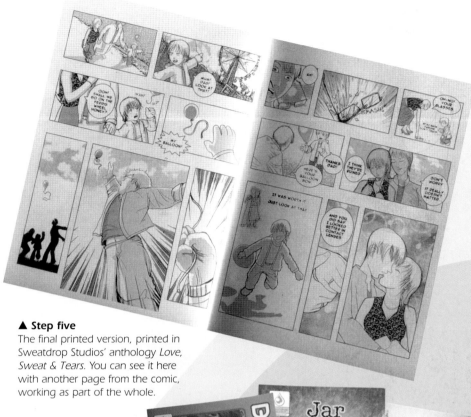

▲ Step five

The final printed version, printed in Sweatdrop Studios' anthology *Love, Sweat & Tears*. You can see it here with another page from the comic, working as part of the whole.

TIPS for Completing Comics

Completing your comic can be very difficult, as it is easy to feel that more could be done to improve the overall piece. The step between almost finishing a comic and actually finishing it can be gigantic, and it helps to have the motivation to wrap up the project.

Deadlines are actually a good thing. It is much easier to prepare a comic for a particular date, whether it's for an event like a convention, or merely a self-imposed deadline. Set a completion date and try your hardest to get it done in time! In professional manga illustration, artists always work to strict deadlines – it's part of the job!

Be realistic about what you can achieve, and you're more likely to be able to complete it. Working on short, single-issue comics before trying to tackle an epic will give you a solid foundation in writing comics, which you can apply to more ambitious projects in due course.

Avoid overworking your comic. There's only so much you can do to each page,

so once it is complete, just move on to the next one. Keeping note of how many pages are complete is a helpful incentive towards finishing each one.

Don't worry about striving for perfection on every single panel. Comics work as a whole, not as a sum of parts, and often a page will look great even if there are small errors in the artwork.

Finally, sacrifice! Be prepared to give up enough time to work on your comic, which can eat up a lot of hours. You may have to pass up on some TV! Comics take time, and while they are great fun, they are also hard work.

Try your best, work hard and create great manga!

▲ Seeing your work in print

Reaching the stage of having a finished and printed comic isn't easy, but finishing the comic gives you a huge sense of satisfaction and achievement.

Web comics

These days, comics are no longer limited to paper and print: your imaginary creations can thrive in the virtual world of the Internet. The Internet has become a wonderful means of exposure for comic artists, both amateur and professional. The international popularity of manga-style comics, combined with the convenience of reading comics online, has allowed even beginners to have a global audience for their artwork and stories.

SAVING FOR THE WEB

Before saving your artwork for the Internet, be sure to flatten your image in Photoshop or Photoshop Elements (collapse the separate layers into a single layer), and then resize the image to the desired resolution. Always save a backup of your original layered and high-resolution digital files, as once an image has been flattened, you can't go back and edit the separate components, as they are now all on the same layer.

Save For Web
Using the Save For Web feature affords you a high degree of control when saving images for use online.

2-up
This allows you to view both the original image and the lower quality Web version, which is useful for direct comparison.

Exported file information
This shows you how large (in terms of file size) the image will be when saved to disk, as well as an estimate of the download time.

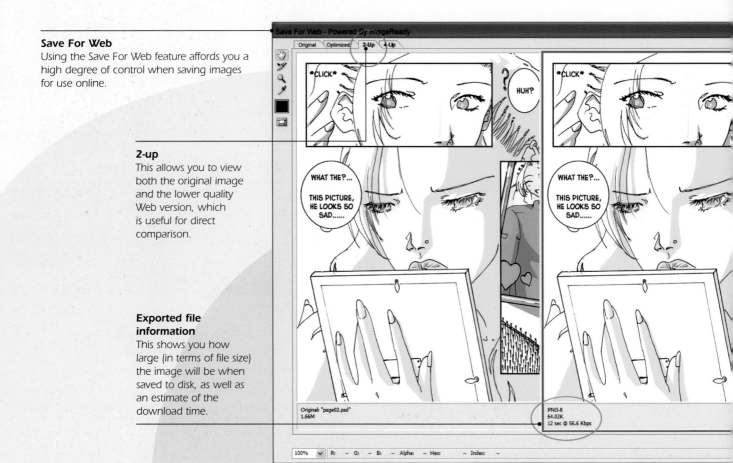

Rabid-Monkeys - Biweekly Online Comic - Mozilla Firefox

Funnies
Short-strip "gag" comics – or funnies – similar to those in newspapers, work perfectly on the Internet. In fact, dialogue-based humour and simple panel layouts work better on screen than in print.

File sizes

When saving images to be viewed on the Internet, the size of the file is very important. This is measured in kb, short for kilobytes. The larger the size, the longer the image will take to download – especially over slow dial-up connections. With the Internet, always design for the slowest system; don't assume your reader has the fastest computer and a broadband connection.

File options

These controls allow you to choose the file format, as well as which compression options you wish to employ to make the file size as small as possible for swift download. As always with the Internet, there is a trade-off between image quality and file size.

ImageReady

You can make a number of further, more sophisticated adjustments to images intended for the Internet in Photoshop's companion application, ImageReady (which comes with Photoshop).

FILE FORMATS
JPEG

JPEG compression is a "lossy" compression method, meaning that the image will lose some of the image quality every time the file is saved. This file format is great for photographs or full-colour comics, as it can keep the file sizes low. However, it suffers from "JPEG artefacts", a form of image corrosion often evident around line art and flat areas of colour.

PNG

PNG is the most recent of the popular Internet file formats, and offers a good compromise between compression and file size. PNG images do not suffer from artefacting like JPEGs do, so the quality of the image is much higher, but the file size will be larger as a result. Unfortunately, some old Web browsers don't support PNGs, so using this format may cause inconvenience to a small percentage of readers.

GIF

GIFs have been mostly superseded by PNGs in terms of how useful they are. However, they offer some options for simple animation, as well as transparency. They are also supported by more (older) browsers than PNGs are, so despite the extra file size, they are sometimes worth considering for line art and graphics (they are far from ideal for photographs).

Resolution

When saving a file intended for display on the Internet, it is important to pay attention to the size of the image. Different people use different sizes and resolutions of screen, so ensure that most will be able to read varying sizes of comic page comfortably. People usually save their image relative to the width of the page, so sizes such as 600 to 750 pixels wide are popular. Be sure to look at other Web comics and decide what pixel width you like best.

Simple colouring

Working in colour is just as easy as greyscale when it comes to Web comics. Experimenting with ways of colouring your comics can give your pages more life – and a distinctive look.

Cutting costs

Web comics are a great way to produce colour comics, without the drawbacks of printing costs.

Costs

Web comics cost almost nothing to post online. Free Web hosting for Web comics is available, and even paying for your own hosting is very inexpensive. Web comics are a low-cost risk compared to printing, and diminish all those worries about not making back the printing costs!

Feedback

One of the advantages of Web comics is that you can get immediate feedback from fans of your comic. However, if people dislike your comic for any reason you also have to be prepared for negative criticism. Focus on the comic itself more than the feedback, and persevere with the production of the story you intend to write.

Professionalism

It is very easy to put pages of manga on the Internet, but this has encouraged some artists to be sloppier with the work they do for online comics. Not inking the lines or using bad, handwritten text makes their pages an eyesore. Try your best to make each page as good as it can be.

A wider audience
Some artists choose to put their printed comics on the Internet. Some people enjoy the comic on the Web so much that they will buy the printed edition to keep.

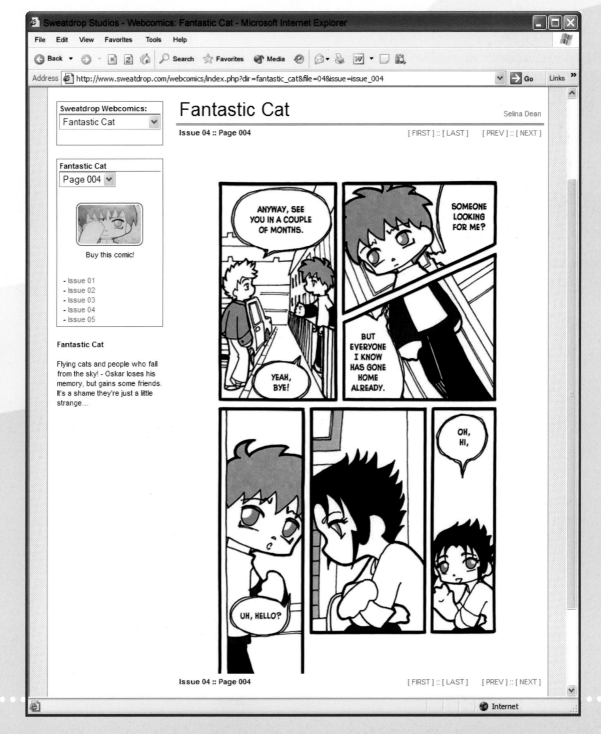

Printing and publishing

Now comes the time for you to bring your work to the public – it's time to print and, with luck, publish, adding your manga to the brilliant comics you admire in the shops and online.

PREPARING YOUR WORK

If you're going for traditional paper-based publishing, when your pages are complete and you have finished lettering you are ready to prepare your pages for print.

Self-publishing is an excellent means for independent and amateur artists alike to produce their own comics. It gives you total creative freedom over what you produce – perhaps greater freedom than even professional artists enjoy! Independent artists can produce every part of their publication – not just the comic itself, but also the cover and layouts, and any additional design work within the comic. If you pay to have copies made at a local print shop, or even just use a conventional colour or black-and-white photocopier, you can produce a printed comic with solid production values.

However, whether you are publishing your work without any outside help or getting it printed professionally, it is important to pay attention to printing specifications.

Flatten your artwork

Before submitting your artwork for print, flatten the layers. This will reduce the size of the file, and make it less likely that there will be any errors in the print process. But before you do this, remember to copy the original, unflattened file first, and only flatten the copy. Retain the original layered file so you can go back and edit the separate components later if you need to. With layered artwork, you have the freedom to easily recolour, add screentone or alter the text and dialogue – you can't do this on the flattened version without going to a great deal of trouble!

Colour printing and CMYK colours

Colour pages are printed using the CMYK process (short for cyan, magenta, yellow and black) inks. These four inks combine on paper to simulate the spectrum but struggle to represent some tones accurately.

Photoshop allows you to specify whether to make your document in CMYK or RGB (red, green, blue) modes, but you should always convert to CMYK for print. (For "comic"

◀ **CMYK in Photoshop**
Photoshop will display an alert if a chosen on-screen colour won't print accurately in CMYK inks. Press the '!' symbol to adjust the chosen colour.

think "CMYK!") Converting the document from RGB, used by computer monitors, to CMYK will often change the appearance of your chosen colours, as certain tones that display accurately on screen are difficult to reproduce in print, but switching to CMYK will give you a better idea of what the final printed results will be. Colours such as purple will sometimes print slightly differently than you expect. Use the CYMK picker tool to help accurately choose print colours in Photoshop.

PRINTING FROM HOME

It is possible to print your own comics at home with a laser printer. The inks used in laser printers are similar to those used in a photocopier – high quality and waterproof – but can struggle with large areas of black. Although significantly cheaper to buy, inkjet printers are not suitable for creating sellable comics, as the inks will smudge when the pages are handled. Check Peripherals on pages 46–47 for more information.

PRINTING WITH PHOTOCOPIERS

With self-publishing, it is important to be able to print small runs of comics, as it is likely they will only sell slowly – quantities of 50 or 100 are common, with extra copies printed only if the first batch sells out. The most popular choice for self-printing is to use a conventional photocopying service. Photocopies work well for comics, as the ink is waterproof and doesn't smudge. Check with your print shop to see if there is a discount for a certain number of copies (for example, for more than 100 copied pages), as this can affect how many you choose to print, and also the overall pricing.

Be very specific when you approach a printing firm. Tell them exactly what you want, including sizes, which pages will be colour (for example, "only the outside cover"), and whether you need "bleed" (see page 123).

▲ **Experimentation**
Using cheap services such as photocopying allows artists to release strange and experimental works. These two comics are collections of single-page comic strips, artwork, and previews of upcoming comics.

Taking charge
Self-publishing allows you total freedom about what size of comic you wish to produce.

PRICING

Consider the price of your comic in relation to other comics that are available. The lower you price the comic, the more copies you will sell. However, it is important to cover your costs, as well as to make some extra profit – even if it is just enough to cover some of your other expenses. If your comic is to be distributed or sold by another person or company, typically they will take 20 to 50 per cent of the cover price, so take this into consideration, too. That said, avoid overpricing your comic: charging too much for it will seriously reduce sales, so less people will get to enjoy your hard work.

Free copies

Some artists even choose to give their photocopied comics away for free, but only print a limited number. This can be great publicity and help sell other titles by the same artist.

ANALOGUE MASTERS

A comic is usually made with several pieces of paper laid together, stapled and folded, creating a set of consecutive pages. When photocopying a comic you will need to create a master copy with the pages in the right position, bearing in mind which pages will be printed on the same piece of paper.

A simple dummy copy is made quickly to help lay out the master spreads.

Dummy copy

One of the easiest ways to see what needs to be on each spread of a comic is to make a dummy copy. By making a small book from folded paper, and then numbering and marking the pages, you can easily see which pages should be printed on the same piece of paper.

DIGITAL PRINTING SERVICES

Many printing companies now allow for digital printing. This means that they will take computer files and print pages directly from the data, rather than replicating artwork from a piece of paper. This offers much greater flexibility and control over the production process.

Creating books
Professionally printed books can be put together from collections of stories or collections of comic issues.

FILE FORMATS

TIFF files

TIFFs (Tagged Image File Format) are one of the most popular file formats for transferring pages and artwork. They have the advantage of strong image compression without lowering image quality. Always choose "LZW" compression when saving with TIFF; this will ensure that the file is small on disk but readable on different types of machine.

PDF files

PDF (Portable Document Format) is a format that has made it much easier to produce comics with digital printers. There are no discrepancies when it comes to reading PDF files, and printers often find them easier to deal with. Always use ZIP compression with PDF files, as JPEG compression damages your images and lowers output quality. If your software gives you the option, always choose the earliest version of PDF compatibility. This causes less problems when processing. Photoshop saves files like this as default.

FILE FORMATS TO AVOID

BMP files

BMP artwork is uncompressed and slow to process, with file sizes becoming huge on disk.

JPEG files

The artwork is compressed, and tiny inaccuracies will appear in the tones. Although these may not be immediately visible on screen, a printer can recognize these subtle flaws and draw extra grain around your lines depending upon its calibration.

GIF files

This file format has no information about DPI stored in the file, so the printer may not know how large it should be. File sizes with GIF are no smaller than TIFF.

CHECKLIST TO REMEMBER BEFORE SAVING FILES FOR SUBMISSION:

✱ **Rasterize your text**
Any text that is still "live" and editable will cause problems during printing, with complications in terms of fonts and small changes of size. You should convert your text to pixels before saving the file; this will avoid any problems.

✱ **Flatten your layers**
Multiple layers increase the file size, as well as making it more difficult for the printer to work with the file.

✱ **Convert to greyscale**
Converting to greyscale will make your file significantly smaller than if you leave it as full colour.

✱ **Check your DPI and page size**
You can adjust DPI without changing the page by setting all other values to 100% before adjusting DPI.

GENERAL PRINT FIRM ADVICE

An unfortunate fact when dealing with printing is that you can't always predict the results. The artwork may appear slightly lighter or darker than you intended. Getting a proof is important so that the printer knows in advance if you are happy with the quality of the printing, and any errors can be spotted before it is too late.

Cooperate with the printing company as much as possible. If you make your print job easier to deal with, staff at the print firm will be more likely to help you if problems occur. If you make it difficult or get angry with them, it will be harder to get the results you want.

Comic series

When creating a series of comics, it is important to unify the front cover designs. Try using the same layout but with different characters on each issue; or use similar design work, but different colours.

Check for "additional costs"

Check to see whether the printer charges a fee for converting the files into a particular format. Savings can be made if you check to see which file formats and format types are most convenient for the printer, saving you unnecessary expense.

Check prices of quantities

If you ask for quotes for different quantities, sometimes it will turn out that ordering more units of the book will cost less. For example, printing more than 1000 "page copies" might save you money. If a comic has 14 sides, printing 72 copies would amount to 1008 sides, and would qualify for a discount. You should also always ask for round numbers when asking for quantities. Ask for quantities of 50, 100, 150, 200, 300, or similar; otherwise it becomes awkward for the printer to summarize the costs involved.

DELIVERING ARTWORK ON CD

✴ Write your name, phone number and e-mail address on the face of the CD itself, as well as the name of the print job. This will make it easier for the printer to contact you if there is a problem, and avoid the CD getting lost.

✴ If possible, include a "readme.txt" on the CD itself. This should include contact details and a reminder of what is on the CD.

✴ Name your files cleanly and organize them neatly.

NOTE: Some firms may allow you to transfer the files via e-mail or FTP (File Transfer Protocol). Check to see what options they allow for sending files.

FULL-BLEED PAGES

When using a professional printer, the comic is often printed larger than the intended final size and then trimmed down. As a result, this allows the inks on the paper to go up to the very edge of the page – something you can incorporate into your design.

Full bleed
This allows panels to drift off the edges of the page, suggesting a larger event beyond the scope of the image.

Bleed area
This area will be trimmed off by the printer, and should be expected to be missing in the final print.

Trim area
This margin area should only contain simple artwork, as this will be drifting off the edge of the paper.

Safety area
It is recommended that text should not be placed in the safety area, in case of any radical printing shifts, and also to avoid text being trapped in the centrefold of the book.

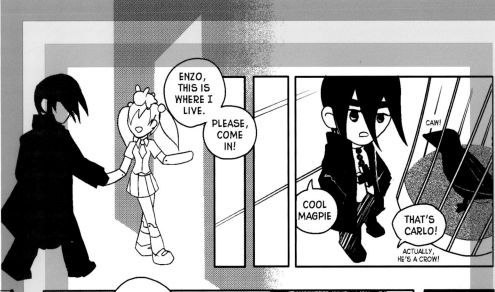

Resources

MANGA CREATOR SITES
Hayden Scott-Baron: **www.deadpanda.com**
Sweatdrop Studios: **www.sweatdrop.com**
Selina Dean: **www.noddingcat.net**
Emma Vieceli: **emma.sweatdrop.com**
Laura Watton: **www.laurawatton.co.uk**

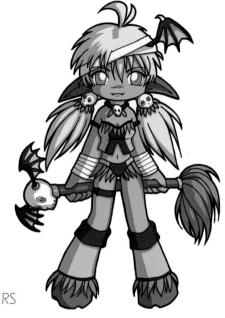

MANGA PUBLISHERS
Viz: **www.viz.com**
Tokyopop: **www.tokyopop.com**
Dark Horse: **www.darkhorse.com**
Iron Cat: **www.ironcat.com**
CMX: **www.dccomics.com/cmx/**
ADV Manga: **www.advfilms.com/manga.asp**
CPM Manga: **www.cpmmanga.com**
Broccoli Books: **www.broccolibooks.com**
Seven Seas Entertainment: **www.gomanga.com**
Go!Comi: **www.gocomi.com**

ART PRODUCT MANUFACTURERS
Letraset: **www.letraset.com**
Deleter: **www.deleter.com**
Copic: **www.copicmarker.com**

COMIC FONTS
Blambot: **www.blambot.com**
Comic Book Fonts: **www.comicbookfonts.com**
Ban ComicSans: **www.bancomicsans.com/fonts.html**

ART SUPPLIES ONLINE SHOPS
Akadot: **www.akadotretail.com**
Dinkybox: **www.dinkybox.com**
Blue Line Pro: **www.bluelinepro.com**
Anime Gamers: **www.animegamersusa.com**

SOFTWARE
Adobe Photoshop: **www.adobe.com**
Corel Painter: **www.corel.com**
Paint Shop Pro: **www.jasc.com**
Deleter Comicworks: **www.comic-works.com**
OpenCanvas: **www.portalgraphics.net**
GIMP: **www.gimp.org**
Deleter CG Illust: **www.cgillust.com**
Corel Photopaint: **www.corel.com**
Macromedia xRes2: **www.macromedia.com**

IMAGE HOSTING GALLERIES
Art Club: **www.sheezyart.com**
Dev Art: **www.deviantart.com**
Elfwood Fantasy Art: **http://elfwood.lysator.liu.se**
Manga Workshop: **mangaworkshop.net**
Digital Art and Design: **http://digitalart.org/**
Artist and Image Database: **www.artwanted.com**
Online Art Gallery: **http://www.side7.com/**
Forum for Artists: **http://www.shadowness.com/**
Virtual Gallery: **http://www.vladartgallery.com/**

WEB COMIC HOSTING
Keenspace: **www.keenspace.com**
DrunkDuck: **www.drunkduck.com**

ART COMMUNITIES
Dream-grafix: **www.dream-grafix.be**
Sweatdrop Forum:
www.sweatdrop.com/forum
Artist Café: **forums.firefly.nu**
Pendako: **pendako.syste.ms/bbs**
Gaia Online: **www.gaiaonline.com**
Cgtalk: **www.cgtalk.com**

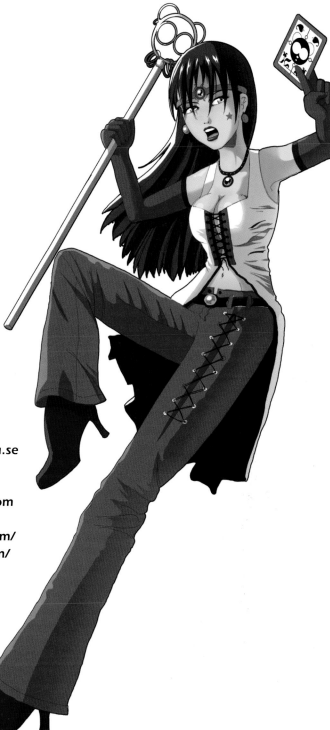

Index

A

abstraction 109
accessories 41
acrylic style 81
action: scenes 18–19
 in shounen 14
airbrush, digital 74–77
animals, supporting 37,
 38–39
antagonist 32–33, 34
anti-aliasing 49, 51, 62
anti-hero 28

B

backlighting 77
black: solid 104
 in watercolour style 80
black and white image: to
 colour 68–69
 to scan 56
black and white inversion
 107
blacking out 109
brush/brush pen inking 58

C

CD, artwork on 122
cel-style image 70–73
 lineless 82
character, to define 16, 41
characters: catalyst 34–35
 child 36–37
 comic 20–21
 female in male role 30
 one-dimensional 24
 protagonist, female 26–27
 protagonist, male 24–25
 supporting 37, 38–39
 teenage boy 28–29
 teenage girl 30–31
 villain 32–33
children: characters 36–37
 representation of 13
CMYK colours 48, 118

resolution 53
coarse tone 89
colour: to add 109
 background 62
 to change 73, 77
 CMYK 118
 on Internet 116
 and lighting 69
 palette 109
 theory 69
 tolerance 51
 tones 72, 73
colour printing 118
colour schemes 41
colouring: black and white
 outlines 68–69
 cel-style 70–73
 greyscale outlines 66–67
comedy 20–21
comic series 122
Comicworks 49
 to rotate image in 60
 screentones 88, 90
completion 112–113
computers: peripherals
 46–47
 software 6, 48–49
contrast 108
costs 117, 120, 122
costume: contemporary 24,
 26, 28, 30, 32, 37
 design 40–41
 fantasy 16, 17, 25, 27, 29,
 31, 32, 36, 40
 historical 33
 science fiction 25, 27, 29,
 31, 32, 40

D

deadlines 113
digital painting packages 49
digital printing services
 121–123
dingbats 99

DPI (dots per inch) 53
 to adjust 121
dummy copy 120

F

fantasy 16–17
 female character 27, 31
 male character 25, 27
 villain 32
 world, to create 42–43
file formats 115, 121
file size 115
fineliner inking 59
font size 111
funnies 115

G

geometric tones 89
gods/deities 43
gradient tones 89
graphics packages 48
graphics tablet 6, 47, 60
grey layers, to keep 90
greyscale image: to colour
 66–67
 line art 62
 resolution 53
 to scan 56
gutter 103

H

hair colour 41, 72
halftone 88
historical sources 17
Hokusai 6
hyperstylization 10, 11, 21

I

iconography: shoujo 13
 shounen 15
idealization 14
inking: digital 60–61
 pages 104–105
 special effects 106

traditional 58–59
Internet: colour on 116
 feedback on 117
 manga on 6, 114–115
 resolution 116
 to save work for 114–115

L

layers 51, 52
 to flatten 52, 114, 118
 to mask 52
LED optical mouse 46
lighting 69, 108
line art: black and white 63
 digital 62–63
 greyscale 62
 to scan 56, 57
line width 59, 104
lines, coloured 87
lineweight 14
LPI (lines per inch) 88

M

magical powers 42, 43
manga: for boys (shounen)
 14–15
 development of 6
 for girls (shoujo) 12–13,
 97, 106
 on Internet 6, 114–117
 themes 16–17
master copy 120
minimalism 10
moiré 88
motion blur 106

N

natural media, to simulate
 78–81
nib inking 59
noise tones 89

O

oil paint style 78–80
Open Canvas 49

P

pacing 103
pages: full-bleed 123
 to ink 104–105
 to plan 102–103
Painter 49
 natural media styles in 80,
 81
 to rotate image in 60
Paintshop Pro 48
panels: to adjust 104–105
 to group 103
 outlines 105
 size 103
pencil work 59
 to scan 57
photocopying 119
Photoshop 48
 airbrush 74
 basics 50–51
 Elements 48
 Layers 52
 print colours 118
 to rotate image in 60
 screentones 88
 special effects 94
 tools 50–51
pixels 53, 62
pricing 120, 122
printers 46, 119
printing 118–119
 professional 121–123
protagonist: female 26–27
 male 14, 24–25
 in shounen 14
 teenage boy 28–29
 teenage girl 30–31

R

races and creatures 43
realism style, lineless 85–87
resolution 53, 57
 on Internet 116
robots 15
rotating the image 60

S

scanner, flatbed 6, 46
scanning 56–57
science fiction 16
 male character 25, 29
 female character 27, 31
 villain 32
screentones 11, 49, 88–89
 to apply 90–93
 to colour 109
 software 90
 special effects 107
self-publishing 118–123
setting, to create 42–43
shading 108
 airbrush-style 74–77
 cel-style 70
shadows 70
shift key 105
shoujo manga 12–13, 97,
 106
shounen manga 14–15
show through, to avoid 57
sketching, digital 61
skin tones 41, 72
special effects: emotional
 wisps 98
 foundations 94
 gritty angst 98
 impact swirl 96
 impact zoom 95, 96
 inking 106
 screentone 107
 sentimental pattern 99
 shoujo sparkles 13, 97
speech bubbles 110

speed lines 14, 15, 106
spirit signs 43
splicing images 57
styles: acrylic 81
 airbrush 74–77
 animation 70
 cel 70–73
 fantasy 17
 lineless 82–87
 oil paint 78–80
 shoujo 13
 shounen 15
 watercolour 80
stylization 10

T

teenager: female 30–31
 male 28–29
text: background 111
 to rasterize 121
thumbnails 102–103
 dialogue in 103
tone, to add 108
tone feathering 89

U

Ukiyo-E art 6

V

visual abstraction 12
visual grammar 10–11, 20

W

watercolour style 80

Credits

AUTHOR ACKNOWLEDGEMENTS

I'd like to thank Selina, Emma and Laura for their wonderful illustrations and support throughout this project; the editors at Quarto for their patience and encouragement; and everyone at Sweatdrop Studios for producing amazing manga and proving that anything can be achieved with teamwork.

PICTURE CREDITS:

Quarto would like to thank and acknowledge the following artists for supplying images reproduced in this book:

(Key: l left, r right, c centre, t top, b bottom)

Sam Brown 119br; Selina Dean 13tl, 13bl, 13bc, 15tc, 15tr, 17, 20, 21, 27l, 29l, 31r, 33l, 35b, 36l, 38t, 39tl, 40br, 42t, 58, 59, 66tr, 81t, 81br, 82r, 84b, 87br, 88br, 109b, 117, 119bl, 120t, 120bl; Sonia Leong 122t; Fahed Said and Shari Hes 115t, 116b; Sweatdrop Studios 113b; Emma Vieceli 6l, 12, 16, 25l, 27r, 29r, 33r, 34, 36r, 40t, 41br, 42b, 43b, 69br, 95b, 99br, 106tl, 108r, 109tl, 109tr, 110bl, 110br, 118b; Laura Watton 1, 6t, 14, 25r, 30, 37t, 38b, 39tr, 41t, 78r, 104tl, 106tr, 110tl

All other illustrations and photographs are the copyright of Quarto Publishing plc. While every effort has been made to credit contributors, we apologize should there have been any omissions or errors.